# FAIR LAWN

## NEW JERSEY

### HISTORIC TALES FROM SETTLEMENT TO SUBURB

### JANE LYLE DIEPEVEEN

*For Doris*
*Best wishes*
*Jane Lyle Diepeveen*

Charleston — London

THE
History
PRESS

Published by The History Press
Charleston, SC 29403
www.historypress.net

*Front cover, top*: Plaza Building. *Photograph by Laurence Koplik.*
*Front cover, bottom:* Underpass connecting A block and B block.
*Courtesy of the Radburn Association.*
*Back cover, top:* Dutch House. *Photograph by Laurence Koplik.*
*Back cover, bottom:* Railroad station, photographer unknown. *Courtesy of Joan Rocamora.*

First published 2010

Manufactured in the United States

ISBN 978.1.59629.698.5

Library of Congress Cataloging-in-Publication Data

Diepeveen, Jane Lyle.
Fair Lawn, New Jersey : historic tales from settlement to suburb / Jane Lyle Diepeveen.
p. cm.
Includes bibliographical references.
ISBN 978-1-59629-698-5
1. Fair Lawn (N.J.)--History. 2. Fair Lawn (N.J.)--History--Sources. 3. Fair Lawn (N.J.)-
-Biography. 4. Historic buildings--New Jersey--Fair Lawn. 5. Radburn (N.J.)--History.
I. Title.
F144.F18D54 2010
974.9'21--dc22
2009047452

# Contents

# Foreword

To many residents of the suburbs who arrived after World War II, the history of their towns and indeed their development seems to have started at the time they moved in. Passing under the radar is the history of the region that dates back at least twelve thousand years to its occupation by the Native Americans. Although there is no written record of that time, there are artifacts that document the life and culture of the indigenous people. Extensive archives trace New Jersey's "modern" history back to a land grant given by the Duke of York to Sir George Carteret and John, Lord Berkeley. The land was later split into the East and West Jersey Proprietorships, which were subsequently divided and re-divided into patents awarded to new owners.

Although Fair Lawn is a borough that was incorporated only in 1924, it was peopled from very early on. Elements of the history exist in archives of county historical societies, New Jersey archives, local museums, newspapers, census data and other online sources. But there has not been a recent effort to gather all the information about Fair Lawn together in an accessible form.

Jane Lyle Diepeveen, Fair Lawn's official borough historian, has accomplished this task with *Fair Lawn, New Jersey: Historic Tales from Settlement to Suburb*. Ms. Diepeveen is a longtime resident of the community and founding trustee of the Fair Lawn Historic Sites Preservation Corporation. She brings her personal knowledge of Fair Lawn, as well as a private collection of archives, memorabilia and photographs, to the task.

# FOREWORD

This work should be in the home of every resident and ought to be used as a resource by children studying their town. I am delighted that someone has expended the effort to put all this material together in such an informative and, I might add, entertaining way. Each chapter is likely to elicit "I didn't know that" or "really?" The book is hard to put down once you get started!

Elaine B. Winshell
Former Borough Councilmember, Fair Lawn

# Acknowledgements

There are many people to thank for aiding me in the enterprise of producing this history of Fair Lawn. Thanks go first to my husband Neal for his patience with my long hours at the computer and for his technical assistance with that machine, and next to my friend and fellow author, Elaine Winshell, for writing the foreword and reviewing the text.

My mother, Kathryn Lewis Lyle, instilled in me a love of old buildings and interest in good government, and my grandmother, Martha Hyde Lewis, introduced me to the fascinations of genealogy.

Many people helped with the task of finding pictures that had not been used in a previous book. Dave Bostock of the Radburn Association, Evelyn McHugh and Felice Koplik generously gave of their time to furnish me with images from their collections; Larry Koplik and Marc Colyer donated photographs they had taken. My daughter Laura Campbell and my friend Artie Nadelle worked diligently to improve some of the images.

Carol Greydanus Bennett generously took the time to relate her memories of early Fair Lawn and to send photos and memorabilia. Pat Idone graciously furnished information on the Garretsons and their farm. Nancy Terhune searched her records for information on the Cadmus family. Allen Lutins sent me his deed research on the owners of the old houses whose stories are recounted in this book. Eric Bal researched the Vanderbeck family and the tale of Lafayette's visit. Janet Strom, historian at the Bergen County Division of Cultural and Historic Affairs, was helpful as always. Special thanks go to Mayor Mary Burdick, who decided many years ago that the borough

should have a municipal historian and set me on the path of researching and recording the history of Fair Lawn.

I have tried to correct the errors that have appeared in previous accounts, including those that I have written. My website, www.fairlawnhistory.com, will provide additions and any corrections that may be made to this history.

# Introduction

The history of Fair Lawn is a history of settlements and the people who established them. First came Sloterdam, extending along the east shore of the Passaic River from today's Garfield into Fair Lawn. Then followed Dunkerhook, Wagaraw and Zabriskie's Mills, located at three corners of the town of today. These settlements extended into neighboring Paramus or Hawthorne. Zabriskie's Mills was later known as Red Mills and then Arcola. Small Lots extended along Small Lots Road, which later became Fair Lawn Avenue. These settlements were principally groups of farms with a mill and sometimes a school. After almost two hundred years since the first settlement, housing developments came to this area: "the Flats" (later Fair Lawn Center), Columbia Heights and Warren Point started to develop around the turn of the twentieth century. Radburn was started in 1929.

This book is the story of these settlements and the town into which they grew.

# The Lenape: The First Inhabitants

When David Danielson secured part of the Sloterdam Patent in today's Fair Lawn from the East Jersey Proprietors, he also obtained a deed from the Native Americans who occupied the area. Spotted Tail, representing the local band of Lenapes, made his mark on the document. The Lenape people, a branch of the Algonquians, occupied all of New Jersey and adjacent parts of Delaware, Pennsylvania and New York; they called their homeland Lenapehoking (pronounced *Len-a-pay-hawk-ing*). The European settlers called them the Delaware, and until recently, historians referred to them as Leni-Lenape. Lenape means "common" or "ordinary people." A 1999 *Record* newspaper article by Richard Cowen quotes George Deck, a Leni-Lenape descendant, as saying that Leni-Lenape means "First People."

William Penn wrote the *Account of the Lenni Lenape or Delaware Indians* in 1683 after learning of their ways while negotiating with them for land. His account of the customs of the Lenape of his area is in accord with the descriptions of later historians of Bergen County and other New Jersey areas. Penn noted: "Their government is by Kings, which they call *Sachema*." At the time of the early Dutch settlers, Oratam was the sachem, or leader, of the Ahkinkeshaki (Hackensack) band that populated Bergen County. The sachems were not autocratic rulers but usually older or wiser leaders who presided over the discussions of the clan and tried to persuade the others to come to a sound decision in regard to making war, settling a peace or, later, selling land to the Europeans.

The first people arrived in New Jersey about twelve thousand years ago, but it is not known whether these were the Lenape or some earlier group. These first arrivals were hunter-gatherers who hunted large and small game with spears and gathered wild food. The glaciers of the last ice age had not retreated far, and the climate was cold and damp. So much of the ocean was locked in the glaciers that land extended almost one hundred miles from the present coast of New Jersey. Gradually, the climate grew warmer, the sea level rose and the northeastern part of today's United States became covered with forest. The population was so sparse that there was still plenty of space for the people as the sea gradually covered the land. The woodlands and the plentiful animals and fish provided the Lenape with food, clothing and materials for houses. Pottery for cooking and storing food and for making tobacco pipes was first made only about three thousand years ago, and the bow and arrow for better hunting came into use about fifteen hundred years later. As game became scarcer about 1000 CE, the people learned to cut down trees, burn the stumps and the brush and plant corn, beans, squash and, sometimes, tobacco.

When the Europeans arrived in New Jersey, the Lenape were living in small villages of twenty-five to fifty people, sited by streams or lakes. The villages consisted of groups of "wickams," or wigwams. A wigwam was fashioned from a ring of saplings bent into a dome shape and covered with large shingles made of tree bark or grass mats. Heat came from a fire in the middle of the wigwam; a hole in the roof allowed the smoke to escape and let in some light. There were no windows, only a door covered by an animal hide when it was rainy or cold. Sometimes the village had a longhouse, also made of bent saplings and bark. The longhouse was used by several families together for sleeping and for cooking when the weather was cold or rainy.

## EVIDENCE OF THE LENAPE IN FAIR LAWN

Arrowheads and other Lenape artifacts were continually turned up by farmers' plows from the time Fair Lawn was settled by Europeans until the last farm was abandoned. Trails made by the Indians were used and gradually widened by the new settlers until they became roads. Trails along the Passaic River and paths leading from fords in the Passaic to the Saddle River are now River Road, Fair Lawn Avenue and Broadway. The trail along

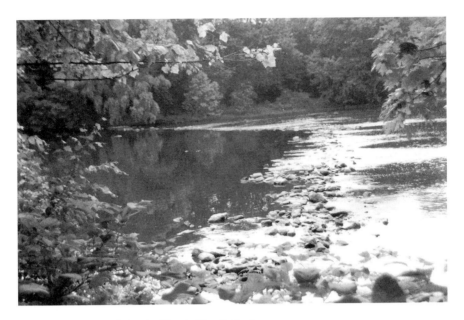

Fair Lawn–Paterson fish weir. *Photo by Tony DeCondo.*

the Passaic led to the huge rock in Glen Rock that was believed to have been a meeting place for Lenape councils or ceremonies.

The most visible evidence of the original people is the fish weir in the Passaic River between Fair Lawn and Paterson. The stone weir can be seen, when the river is low, two hundred yards upstream from the Fair Lawn Avenue Bridge. Alanson Skinner and Max Schrabisch wrote in 1913 that there were then eleven Indian fish weirs in the Passaic River. The weir was a fish trap that made it easy for the Lenape to catch shad, striped bass and alewives as they swam up the river from the ocean to spawn or to catch eels when they swam down the river to spawn in the ocean. The Fair Lawn weir is a low dam made of stones and boulders in the shape of a shallow V extending the width of the river. At the point of the V, which is oriented downstream, there is a gap, or sluice.

There are several theories as to how the Indians used the weirs. One is that when the fish swam upstream in large schools, they would be diverted by the angled walls of the dam to the shallow sides of the river, where it would be easy to scoop them up with nets or baskets. Also, when the eels came downstream they could be caught in a net stretched across the narrow dam opening. Another theory is that the Lenape would trap the fish upstream of

the dam, either by stretching a net across the river or by beating the water to force the fish toward the dam. The opening in the dam would be closed by a net, a small bush or a bunch of small branches so that the fish could be easily speared or caught in baskets. William Nelson of the Paterson History Club, writing of Lenape place names in 1904, stated:

> *AQUACKANONCK—...is probably from Achquanti'kan-ong, "Bushnet fishing place." Zeisberger wrote "Achkquanican, a fish dam." The locative* [sic] *was a point of land formed by a bend in* Pasaeck *River on the east side, now included in the City of Paterson...The Dutch wrote here Slooterdam, i.e. a dam with a gate or* sluiceway *in it, probably constructed of stone, the sluiceway being left open to enable shad to run up the stream, and closed by bushes to prevent their return to the sea.*

Zeisberger (first name not given) wrote the *Indian Dictionary* in 1887, according to Nelson. This interesting entry gives both the Lenape and Dutch words for the weirs, but we must remember that widely varied meanings of Indian names are given by different sources. It also gives us another dam location and another theory of how the weirs were used. Perhaps different methods were used depending on the season.

Another weir in the shape of a W has been found in Fair Lawn a half mile downstream from the first one. This is harder to see, being visible only when the river has been drawn down by drought or work upstream. There are also the remains of a weir near the Dundee Dam at Clifton. Skinner and Schrabisch noted an upland, adjacent to the Fair Lawn V-dam, containing prehistoric artifacts, which they surmised was a Lenape workshop. Most of this area has been disturbed by sand and gravel mining and the construction of the former Sandoz plant, but there may still be some undisturbed area that could be the subject of an archaeological investigation.

The Lenape gradually sold or granted their lands to the European settlers and moved west to the Delaware River. Large numbers of the native people died from European diseases for which they had no natural immunity. Those who remained moved farther west, first to Pennsylvania and Ohio and finally to Kansas and Oklahoma. They left behind the heritage of the many Lenape place names we use today: Hackensack, Hohokus, Paramus, Wagaraw and Passaic in our area, and many others throughout the state.

# Sloterdam:
# Garretson Farm and the First House

The Garretson Forge and Farm Restoration museum is the site of the earliest settlement in Fair Lawn of which we have a record. In 1708, David Daniellse (also spelled Danielse) acquired a large tract of land, part of the Sloterdam Patent, from Jeremiah Stillwell and Roelof Verkirck. Spotted Tail, representing the native Hackensacky people, also made his mark on this deed. The document is now in the archives of the Garretson Museum. This deed relates that all the land from the confluence of the Passaic and Saddle Rivers to the "line of the Indian purchase" extending from the "great Rock" to the Saddle River was conveyed to a group of nine men in 1867 by the "proprietors of the Province of east New Jersey." Stillwell and Verkirck had acquired the land that they sold to Daniellse from the original group of nine.

The East Jersey Proprietors was a company, formed by William Penn and twenty-three others, that bought all of East Jersey from the estate of Sir George Carteret in 1682. Carteret and John Lord Berkeley had been given all of New Jersey by James, Duke of York, in 1664 when England took New Netherlands from the Dutch. The two men later split the state into east and west portions. The East Jersey Proprietors was the oldest corporation in the state when it was dissolved in 1998.

The area along the east bank of the Passaic River was known as Sloterdam after the fish weirs constructed by the Native Americans in the Passaic River. The Dutch settlers called these "sloter" dams, meaning "shutting" or "closing" dams. (Later spellings were Slotterdam, Slooterdam and Slaughterdam.) The road along the Passaic River was known as Sloterdam Road.

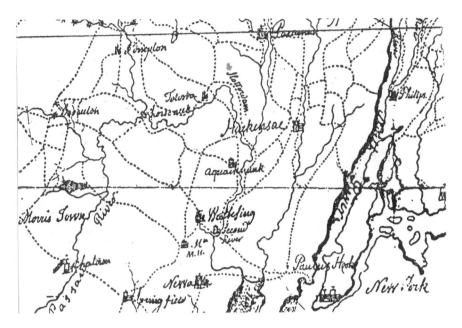

Section of a British war map, 1780. *From* Washington and the "The Enterprise against Powles Hook," *by William H. Richardson.*

The Sloterdam Patent was bounded by the Passaic and Saddle Rivers and included land comprising what are now the boroughs of Garfield, Elmwood Park and Fair Lawn and part of Glen Rock. It is not clear whether Daniellse's land extended to present-day Fair Lawn Avenue or only to a tract south of Fair Lawn Avenue owned by a Garretson family member.

Daniellse would have farmed his land, as was usually required by the terms of the deed, and there may have been farm buildings or a workers' hut on the Fair Lawn part of the property. Two historians state that a stone dwelling existed on the property prior to Daniellse's acquisition of the farm. If this is true, we cannot be sure that it is part of the present house; other sources say that the older part of the house was built between 1720 and 1725 by Peter Gerritse, who, with his father, Gerrit Gerritse, bought the Fair Lawn portion of the land from Daniellse in 1719. In either case, this southwestern wing is the earliest house we know of in what is today the borough of Fair Lawn and certainly the oldest structure remaining in the borough. The larger, eastern wing was built, according to various authors, either about 1750 or 1800. The building is known as the Garretson House for its long ownership by several generations of this family.

18

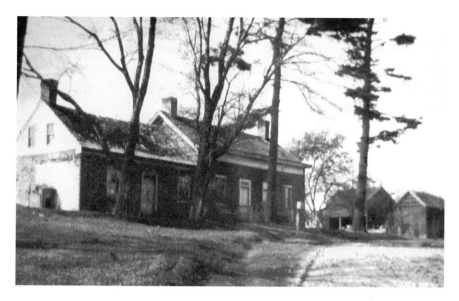

The Garretson House before modern additions. *Courtesy of the Cadmus House Museum.*

Peter Gerritse was the son of Gerrit Gerritse, who was a judge of the Bergen County Court at Bayonne. Gerrit's father, also Gerrit Gerritse, had come to New Netherland in 1660 and settled at Communipaw, today's Jersey City. Other members of the family also bought land between the Passaic and Saddle Rivers, south of Daniellse's property. Peter Gerritse apparently did well as a farmer, since at his death in 1766 he owned at least six slaves, according to his will. Slaves were important as laborers on the large farms of this era and were also employed to quarry and dress the sandstone used to build the houses. It was usually slave labor that sawed the stone into the neatly squared and coursed masonry used for later additions to the early houses, so that it may have been Peter who built the main block of the house.

The main section of the home was originally a two-room addition with gable roof, typical of many early stone houses built by the settlers from the Netherlands, including several in Fair Lawn. There were fireplaces at each end of the house and an entrance door and a window on the front wall of each room. (One of these doors has been made into a window.) The south wing has two smaller rooms and a fireplace with a beehive oven at one end. The oven is a reconstruction based on evidence of a former oven at the location. The current gambrel roof, dormer windows and porch are later additions made about 1902. The small greenhouse may have been added at this time also.

A forge is reputed to have been on the property, as supposedly noted on one of the maps made by surveyor Robert Erskine for General Washington during the Revolutionary War. The *Garretson Farm Historic Structures Report* of 2007 examined the two Erskine maps of the area and found no indication of a forge, surmising that the nearby "ford" may have been misinterpreted. However, the National Register Nomination form for the property states that "in the work sheds many 17th [*sic*] century tools and forgings were found. Some of these were buried in the dirt floors." And *Bergen County: A Pictorial History* reports that "boxes or iron work such as Dutch-style hinges, hooks and nails have been found in the cellar" as evidence that a forge may have supplied the neighboring farms.

Peter Gerritse's descendants Anglicized the name to Garretson or Garrison. Two of his sons, Johannis and Gerrit, remained at the forge. Descendants of Johannis owned the house until 1950. In 1822, Garret H. Garretson and John Garretson divided their land into two roughly equal long, narrow strips. John's property included the house; another building, probably a barn, was located on Garret's portion. The farm was further divided by sale and inheritance but was still about eighty acres when Mary Garretson inherited the land and the homestead from her father in 1901. Mary, or Mamie, as she was called, married John Smith in 1910. Three years after Smith's death, in 1922, she married Feenix Brocker, to whom she had leased the farm. By 1924, some of the land east of River Road had been sold to the Goldman family, who established the Farmland-Fair Lawn Dairy on the tract. Brocker inherited the remaining property, all west of River Road, upon Mamie's death in 1950.

News of the imminent sale of the homestead for a housing development in 1974 aroused concerned citizens to campaign for the preservation of the property. Led by Lois Horowitz, they founded Garretson Forge and Farm Restoration, Inc., and held many fundraising events. The corporation bought the house, several farm buildings and 1.84 acres of land from the developer in 1975 with a sizable mortgage. In 1977, the Bergen County Board of Chosen Freeholders agreed to buy and maintain the property. Dedicated volunteers, mostly from Fair Lawn, operate the buildings as a museum. The site has been placed on the State and National Registers of Historic Places.

# Dunkerhook:
# Jacob Vanderbeck and His Mill

In 1734, Jacob Vanderbeck of Hackensack bought a large tract of land on both sides of the Saddle River and extending into today's Glen Rock. He established Fair Lawn's second settlement in the section that became known as Dunkerhook, from the Dutch *Donckere Hoek*, meaning "dark corner." He moved his wife, Femmetje, and four young children to the property, and in addition to farming the land, he built a gristmill for grinding grain where Dunkerhook Road crosses the river. He would have built a dam to create a pond with a raceway to power the mill. The millpond and the mill are now gone, but the house he built and a later house remain as evidence of his industry. Dunkerhook Road existed as early as 1767, according to road returns (surveys) in the Bergen County Courthouse.

Jacob's great-grandfather, Paulus Vanderbeek, had come from Bremen, Germany, to New Amsterdam about 1643. He prospered, married a local widow, bought a farm at Gowanus and was one of the patentees of the Brooklyn Patent in 1677. Jacob's father, also Paulus Vanderbeek, moved his family to Bergen County near Hackensack. Jacob later Anglicized his name to Vanderbeck.

Jacob purchased his land from Cornelius Drake and his wife, Marytie. This was a portion of a much larger tract (extending from Ridgewood to Maywood) that had been granted by William Nicolls to Marytie's father, Lawrence Arants Toers. Nicolls was probably a relative of Colonel Richard Nicolls, who, in 1664, was named governor of all the territories of James, Duke of York, extending from the St. Lawrence to the Delaware River. Governor Nicolls granted many

patents for settlements in New Jersey, although some of these conflicted with patents issued by the East Jersey Proprietors who had purchased the colony in 1682 from the estate of Sir George Carteret.

The Vanderbecks' neighbors across the Saddle River were the Zabriskie family. Albrecht Zaborowsky or Sobieski, a cousin of King John of Poland, came to New Amsterdam in 1662 to escape the war in Prussia. In 1682, he bought the "Paramus Tract" or "New Paramus Patent," which lay east of the river. Albrecht's oldest son, Jacob, built a house on the east side of Paramus Road opposite the end of Dunkerhook Road in 1760. The family name went through various spellings in Dutch and English but finally settled as Zabriskie. Albrecht had five sons. The family multiplied and built several houses along Paramus Road over the next generations. At least three stone houses were built along Dunkerhook Road east of the river.

The ownership of the land between the Saddle River and Paramus Road to the east is not clear. Since Vanderbeck's property was described in the Historic American Buildings Survey (HABS) report as being on both sides of the river, he or his descendants may have sold this land to the Zabriskies or their relatives, the Boards and the Wessels, who later owned the houses along Dunkerhook Road. Another possibility is that the deeds or patents to the two properties overlapped and the title was later settled, amicably or through a lawsuit.

Two red sandstone houses, both of which are on the State and National Registers of Historic Sites, stand on the Fair Lawn end of Dunkerhook Road today. Both homes were surveyed by the HABS in 1938–39. This project, a program of the Works Progress Administration (WPA), recorded the fabric and the history of hundreds of historic buildings in the United States in a program that employed architects, draftsmen, photographers and historians in the 1930s. Thus we have photographs, family history and measured drawings showing building dimensions and construction as well as details of mantels, cupboards and windows. Some of the information about the Vanderbeck property was given to the HABS researcher by Mrs. Lawrence Snyder, great-great-granddaughter of John J. Ferdon, who bought the houses and thirty-seven acres of the land in 1839.

The older house, now known as the Naugle-Vanderbeck House, was probably built between 1740 and 1761. The latter is the traditional date, according to the Bergen County Stone House Survey. The earlier one is a surmise by the supervising historian of the HABS study of the house, Walter E. Rutt, who thought Vanderbeck would have built soon after he bought the land.

The other house, known as the Jacob Vanderbeck Jr. House after its later owner, a grandson of the original Jacob, was built about 1785. An earlier wing, believed to have been built about 1754, was torn down before the end of the nineteenth century, and the present east wing and second-floor dormers were added in the early twentieth century. There was a third house close by, known as the Harmonus Vanderbeck House, occupied by another grandson. This was probably the house on the north side of the brook, known today as the Jordan Brook, shown as the property of H. Vanderbeck on the 1867 M.J. Hughes map. This home was destroyed by fire in 1936.

# CURIOUS BUILDINGS

The Naugle-Vanderbeck House is not a typical Dutch stone house. The basement is built into a hillside, with a door and window facing the road. It also has side windows and a large cooking fireplace. This level may have been the family's living space before the upper floor was constructed. The main living space is accessed from higher up the hill by a side door. However, the large living area has the typical wide cooking fireplace and adjacent glassed-door cupboard of all the early stone houses and is connected to the lower floor by a ladder-like stair, so it seems probable that in early times this room was the cooking/eating/living area.

The basement level was then probably used for storage and sleeping or perhaps as a separate home by one of Jacob's four children after marriage. It is said that his daughter, Jannetje, married a man who was paymaster to General Lafayette during the Revolution and that the couple lived in this house after the war. The only other rooms on the first floor are a hall with stairs going up and down and a small storage room, or "birthing room," which was made into a kitchen sometime after 1939. Mel Naugle was born in this room in 1916. The half-story top floor was a later addition but not a modern one. It had no fireplaces, so until central heating was installed the only heat came from the chimneys when there was a fire below. There was no bathroom as late as 1939; the old outhouse is still on the property.

The Jacob Vanderbeck Jr. House standing today was built in the Federal style popular after the Revolution. It is constructed of coursed but undressed red sandstone with a stuccoed south front, a Dutch gambrel roof and a sweeping overhang. There is a Federal-style front door with a glass transom over it, and the fireplace has a handsome mantel with fluted medallions and is flanked by classical Greek columns.

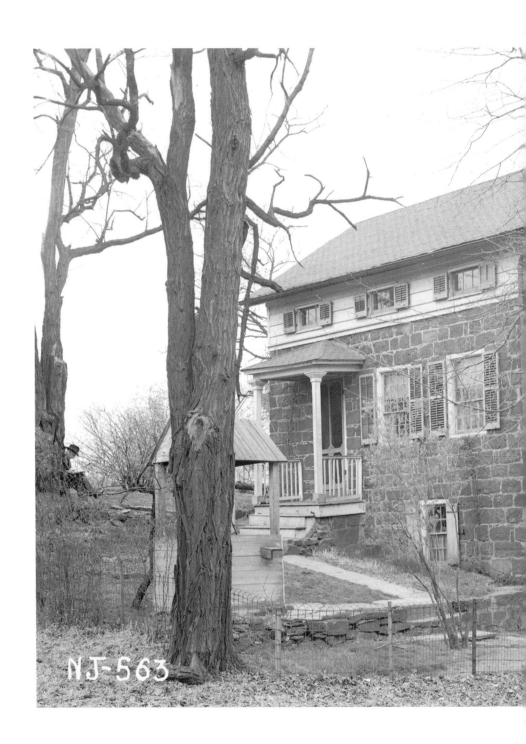

The Naugle-Vanderbeck House in 1939. *From the Historic American Buildings Survey.*

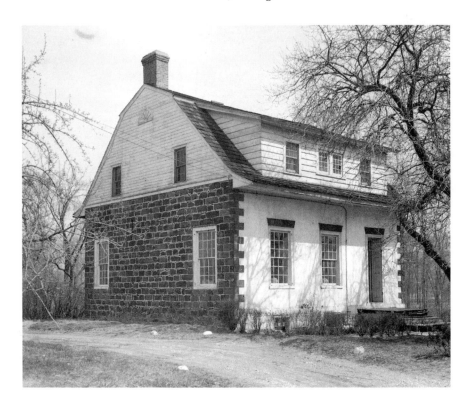

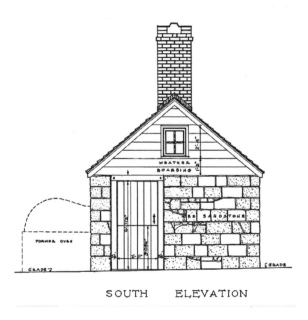

SOUTH ELEVATION

*Above*: The Jacob Vanderbeck House in 1938. *From the Historic American Buildings Survey.*

*Left*: Jacob Vanderbeck smokehouse in 1938. *From the Historic American Buildings Survey.*

The HABS report on this house includes a small square building that is described as an "out kitchen" but is probably a smokehouse, as it has been known since the mid-twentieth century. The 1938 measured drawings show a sandstone building with a dirt floor and a jambless fireplace fitted with a smoke hood. The drawings also show the outlines of a former oven of a curious domed shape known as a beehive oven. This was built outside of the west wall but opened into the smokehouse. The Bergen County Historic Sites Survey for Fair Lawn states that the building was erected in the early 1800s and reconstructed about 1900. However, it is almost identical to the smokehouse at the Jacob Zabriskie Farm Group on Paramus Road also recorded by the HABS. This record states that the house and barns were built in 1826 on the site of an older home but that the smokehouse was from the earlier period. So it is plausible that the Vanderbecks may have built the structure in the 1700s.

The smokehouse is too far from the Vanderbeck houses to have served as a kitchen, but it may have served the Berdan-Ackerman House, which until lately stood on the corner of Dunkerhook and Saddle River Roads and was part of the original Vanderbeck property. This was another old house, much altered over the years into a Victorian style. It reputedly was built in the 1730s, but there is no record of its existence until 1860, when Mary Joralemon sold it to John Berdan Jr., a surveyor. If part of this house was indeed from the 1700s, it would have been built by one of the Vanderbecks.

# FROM FARM TO SUBURBIA

The history of the ownership of the two Vanderbeck houses exemplifies the pattern of development of not only Fair Lawn but also of northeast New Jersey. Jacob Vanderbeck was said to have divided his land, originally "90 Dutch rods," among his three sons—Paulus, Jan and Abram—but we know that the youngest son, Abram, moved to "Schraalenbergh," farther east. At any rate, it was Jan's farm with the two present-day houses that was sold by his son Jacob (Jr.) to John H. Garrison or Garritson (a descendant of the original settler, Peter Gerritse) in 1800. The property was described as being two lots, one of 32 acres including the houses and one of 19.6 acres of meadow and woodland. Jacob and his brother Harmonus evidently kept some of the property north of the present-day Jordan Brook, since we find two Vanderbeck houses there in the atlases of 1867 and 1876. One house

stood near the brook and the other just north of the Glen Rock line on Saddle River Road, where Herold's Farm is today.

When the widow of Garrison's son John J. sold the houses in 1839 to John J. Ferdon, the property was described as two lots but totaled less than thirty-seven acres. We know that Ferdon sold the Naugle-Vanderbeck House and one acre of land to his daughter in 1869, but when the Jacob Vanderbeck House was sold by Ferdon's descendants in 1903, the property still contained two lots and included land in Glen Rock. The house was sold again in 1912 with only twelve acres of land east of Saddle River Road. By then, the entire original tract west of the road had been broken into smaller parcels, although several farms remained. Walter Squire bought the property in 1938 and added the dormer windows and the adjacent kitchen. He sold still another part of the property in 1941, reducing the homestead, now owned by Henrietta Vander Platt, to its present few acres. The Naugle-Vanderbeck House and an adjacent lot have been rezoned for town houses in exchange for a promise to preserve this historic landmark. The once extensive farm has become suburbia.

# Dunkerhook:
# Myths, Facts and the Lafayette Connection

Two stories are told about the Dunkerhook area that have been repeated as oral history and written in published works but have been shown to be not entirely true. One tale is that the houses along Dunkerhook Road in Paramus were slave homes and that the Vanderbeck House was a stop on the Underground Railroad. The other is that a Naugle who lived in the Naugle-Vanderbeck House was a paymaster to General Lafayette during the Revolutionary War and that the general visited his old paymaster during his later tour of the United States. The latter story is mostly fact; the former seems to be mostly conjecture.

## THE DUNKERHOOK ROAD COMMUNITY

Fred Bogert, in his book *Paramus—A Chronicle of Four Centuries*, states that Dunkerhook Road was the location of slave houses built by the Zabriskies, who owned this land, as well as a school for the slave children and a church. Robert Q. Rogers, in his 1960 history *From Slooterdam to Fair Lawn*, also describes a slave community on the Paramus side of the Saddle River, noting that three of the houses were still standing at the time. Neither author provided a source for his statements. The Bergen County Historical Society erected a marker on Dunkerhook Road that states in part: "Along this road, the Zabriskie family…built houses and a school for the use of their slaves."

Where did this story come from, and does it seem plausible? Would the owners really have built separate houses for slaves and a school for slave children? Bogert states that the houses were built before 1800 and the school in 1726, while Rogers claims that the homes were built about 1760. The *Historic Sites Survey of Paramus* prepared by the Bergen County Office of Cultural and Historic Affairs in 1981–82 tells us that the houses were constructed between about 1800 and the mid-nineteenth century, judging from architectural evidence, and refers to two of them as "slave/tenant" houses. The other home, at 273 Dunkerhook Road, is on the State and National Registers of Historic Places as the Zabriskie Tenant House.

The fact that none of the homes appears on the 1778 and 1779 Erskine maps of the area does not prove that they were not there at the time, since neither Dunkerhook Road nor the pre-Revolutionary homes on the road in Fair Lawn are shown on the maps. Several buildings do appear on the 1861, 1867 and 1876 maps. On the last, two are owned by the Wessels family and one by Peter Board. Both families are descendants of the Zabriskies, who originally owned the land. The fourth building is the Zion ME Church.

Allen Lutins, a former Fair Lawn resident, has written a scholarly article, "Dunkerhook: Slave Community?" for the *Journal of the Afro-American Historical and Genealogical Society*, investigating the question of whether the Dunkerhook area really was home to a slave community. His research in census and tax records and records of slave births and manumissions shows that the families in the Dunkerhook–Paramus Road area owned very few slaves, the most being six in 1820. This is hardly enough to be called a community, and there is no evidence that they lived in separate houses on Dunkerhook Road.

When an owner had only a few slaves, they were commonly housed in the attic of the residence. The Historic American Buildings Survey has records of two early Paramus homes in this area. One, called the Jacob Zabriskie Farm Group located on Paramus Road and built in 1826, describes a building near the residence designated as a storage-slave building. However, the plan and elevation drawing of this structure shows a flat-roofed building with barn doors and no windows, called a *sleigh* house—it was not a slave dwelling. The HABS account of the Albert J. Zabriskie House on Glen Avenue, built in 1805, tells us that the slaves were locked in the attic at night and has a drawing of the special lock on the door to the attic.

If there was an African American neighborhood in the Dunkerhook section, who lived there and when? Mr. Lutins's research shows that in 1850, the census recorded three free black families living in separate dwellings and

three teenage blacks residing at the Wessels homestead. By 1860, there were six black or black and "mulatto" households, also in rented quarters. Some households had three generations; some had two families, but whether they were related by marriage is not known. The fathers and some of the sons are listed as "laborer" or servant: coachman, waiter and footman. The houses were not owned by these families, so these dwellings were either provided by the farmers they worked for or were rented.

Mr. Lutins did not investigate the neighborhood of Dunkerhook Road on the Fair Lawn side of the Saddle River. However, the 1860 census for that area shows a free black family living in a house on Fair Lawn Avenue not far from Dunkerhook Road. By 1870, there were two black families at this location and ten across the Saddle River on Dunkerhook Road and Paramus Road. Earlier censuses show other black or "free colored" families in various areas of Fair Lawn and adjacent parts of Bergen County, as well as individual blacks living in the households of farmers and serving as laborers or domestics.

The presence of the Zion ME Church, an African Methodist Episcopal Zion congregation, is the clue to the fact that there was a real community of African Americans in the Dunkerhook area. Most of the black families worked on different farms, but the church was the place where these laborers could meet, socialize and get to know one another. Mr. Lutins's research has determined that the church was built between 1861 and 1867, but the congregation may have existed before that.

The censuses show that some of the African American children went to school, but the old maps, which do show school buildings, do not indicate any in the Dunkerhook area. Mr. Lutins's research in deeds and school listings has found no school in the area. He concludes that there was probably a Sunday school connected to the Zion Church and this was what led to the story of a school at Dunkerhook.

As for the story of the Underground Railroad, there is no evidence that there was a route through Fair Lawn or anywhere near it. According to Wilbur H. Siebert, writing in 1898 in "The Underground Railroad: From Slavery to Freedom," there were three main routes through New Jersey for escaping slaves. They entered the state from Philadelphia or Delaware and all proceeded northeast to New York City via Jersey City or Perth Amboy. There was also a route from Trenton to New York City and a route that ran through Morris County northward to New York State. The story that there is a secret passage used by escaping slaves in the Jacob Vanderbeck House has

no basis in fact. The present owner, Henrietta Vander Platt, has said that no such passage exists. Giles R. Wright, director of the Afro-American History Program at the New Jersey Historical Commission, has stated, in regard to the Underground Railroad, "There is no aspect of black American history that is more popular—or more shrouded in misrepresentation, speculation, fabrication and myth."

## The General Lafayette Connection

A historical marker placed outside the Naugle-Vanderbeck House tells that a Naugle was said to have been a paymaster to Lafayette's Light Division during the Revolutionary War and that the general visited here in 1824. Rogers, in his history, states that "some accounts" say that Naugle worked on Jacob Vanderbeck's farm, married his daughter and built the house. Rogers also says that Naugle was paymaster to Lafayette's troops and that the general's correspondence details his journey from Manhattan to River Edge to visit General Von Steuben and then to Dunkerhook to visit his old paymaster before continuing to Paterson "to have lunch with Alexander Hamilton."

Investigations by the author and by Eric Bal of the First Mountain Chapter of the Sons of the American Revolution have shown that parts of the story are credible but that a Naugle was probably not the paymaster. Furthermore, the visit described by Rogers, said to be taken from Lafayette's correspondence (published by his son in 1837–38), must have taken place not on his triumphal tour of 1824 but during his earlier visit in 1784.

Mr. Bal notes that neither Von Steuben nor Hamilton was alive in 1824. He has found that Lafayette traveled to America in 1784 at Washington's invitation to visit his fellow officers and friends from the Revolutionary War. The general arrived in New York and traveled through New Jersey to Philadelphia and then to Mount Vernon and other parts of the country. This must have been the journey in which he visited his old paymaster, as described in his correspondence.

Could there have been a Naugle at the Vanderbeck farm in 1784? The progenitor of the Bergen County family, Barent Nagel, arrived at Closter in 1710, having bought a 1,300-acre tract of land with his brother, Resolvert. Barent had four sons, at least two of whom and their descendants stayed in the Closter area. (Resolvert had only daughters, so all the early Naugles

were Barent's descendants.) A Closter history tells us that David B. Naugle, a great-great-grandson of Barent Nagel, is the progenitor of "the Paramus Naugles." He was married at Paramus in 1828 and bought the Ackerman-Naugle House on East Saddle River Road in today's Ridgewood in 1861. Also, we know that George Naugle, ancestor of the Fair Lawn Naugles, was living on Broadway in 1850. He bought eight acres of land on Saddle River Road, north of Broadway, in 1860 and moved his family there. George Naugle was the father of Burnet, who married Mary Ann Ackerman's daughter, Rachel, and moved into the Dunkerhook Road house of his mother-in-law. But all the earlier Naugles for whom we have records lived in Closter, so it is not probable that there was a Naugle at Dunkerhook during the Revolution.

The first Naugle at the Naugle-Vanderbeck House may have been Elizabeth Naugle, who married John J. Garrison. He inherited the Vanderbeck houses from his father about 1810, but we don't know which of the two houses he occupied. The widowed Elizabeth sold the land and houses to John J. Ferdon about 1839, the year of her remarriage.

The Naugle-Vanderbeck House was known as the Mary Ann Ackerman House as late as 1949. Her father, John Ferdon, deeded the house and an acre of land to his daughter in 1869. She had married David A. Ackerman and lived with him in Washington Township (now Paramus) but moved into the Dunkerhook House with her children, apparently upon Ackerman's death. Her daughter Rachel married Burnet Naugle, and by 1880 the couple and their daughter Mary Elizabeth had moved into the house with Mary Ann and her grandchild, Sara. The Naugles' son Leslie was born in the house in 1884. When Mary Ann Ackerman died in 1901, she left her home to Rachel. After Rachel's death, her son Leslie was deeded the house, and his son Melvin inherited the homestead. Thus, it became known as the Naugle House. A memento of Mary Ann has recently been discovered in a collection of hand-woven bed coverlets: a reversible coverlet with the name "Mary Ann Ferdon" and the date 1834. Mary Ann would have been twelve years old that year.

If Lafayette's paymaster married the first Jacob's daughter, Jannetje, his name was Jacob Brouwer, and he could have lived in a Vanderbeck house. Mr. Bal has found "Jacob Brouwer of Bergen County" on the official list of New Jersey men who served in the war.

General Lafayette was again in Fair Lawn on his grand tour of the United States in 1824–25. An account by an eyewitness, Abraham A. Terhune, as written by his son Albert D. Terhune, has been transcribed by a descendant, Nancy Terhune of Fair Lawn. Abraham Terhune was a member of the New

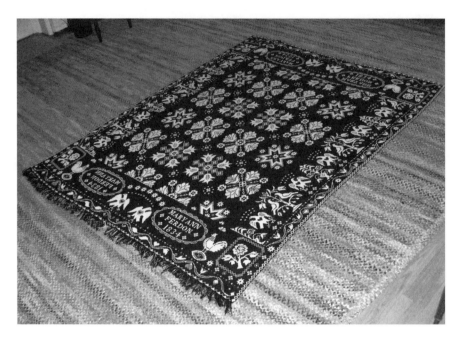

Coverlet made for Mary Ann Ferdon. *Photo by Laurence Koplik.*

Jersey militia and served in the advance guard in Lafayette's progress from Hackensack to Paterson in 1824.

Terhune tells us that the procession marched from Hackensack to "Red Mills" (at the intersection of today's Broadway and Paramus Road), where there was a "great throng of farmers" waiting to greet the hero. The parade then continued across the wooden bridge over the Saddle River through "Small Lots" (Fair Lawn) via "the Slotterdam Road to the eastern shore of the Passaic River; and from this point along the river road to Wagaraw." At Wagaraw, the parade stopped to view the former encampment of Lafayette's troops between Diamond Brook and Wagaraw Brook in Hawthorne before continuing on to a reception in Paterson.

It is not clear from this account whether the route was west on today's Broadway to Sloterdam Road, which is the same as "the river road," or north to Small Lots Road (Fair Lawn Avenue) at Dunkerhook and then east to the river. By either route, the group would have passed the Ryerson House, then on Wagaraw Road in Fair Lawn, where "Light Horse Harry" Lee (see the next chapter) stayed while his cavalry was guarding Lafayette's troops.

# Lost Fair Lawn

As late as 1950, Fair Lawn had ten early stone houses in the Dutch Colonial style and several grand Victorian-style frame houses, as well as other structures reminiscent of the town's history. Six stone houses have been preserved, but the other buildings are gone, fallen to "progress." Fortunately, photos and drawings remain to remind us of the history the structures embodied. No battles were fought in today's Fair Lawn during the Revolutionary War, but some of the residents of the early stone houses joined the local militias that fought on the American side.

## MAJOR LEE SLEPT HERE

Dirck Ryerson built a stone house at Wagaraw, the Lenape name for the great bend of the Passaic River, in the northwest corner of today's Fair Lawn. The house appears on the Erskine maps made for General Washington. Ryerson probably built the house about 1750, after he inherited this property from his father, Frans. Frans Ryerson had purchased six hundred acres of land in this area with his brothers, Joris and Ryer, in 1706 and settled on the tract in today's Hawthorne two years later. The land between Maple and Lincoln Avenues in Fair Lawn was part of his farm, perhaps under cultivation as early as the Garretson property.

The Historic American Building Survey lists the Dirck Ryerson House as the Major Henry Lee Headquarters. In the fall of 1780, Washington ordered the young major, known as "Light Horse Harry" Lee, to guard the approaches to the encampment of Lafayette's soldiers who were stationed along Goffle Brook in Hawthorne. Lee made his headquarters at the Dirck Ryerson House, then occupied by Ryerson's widow and their teenage children. Lafayette was staying at this time at the home of John G. Ryerson (Dirck's cousin) on today's Goffle Road in Hawthorne, but he was camping out in a tent in what he called his "Light Camp." Lee may have done the same, as the house at this time probably consisted of only one fourteen- by twenty-three-foot room with a garret for sleeping. A historic marker, erected by the Daughters of the American Revolution in 1930, attested to Lee's presence at the house.

Henry Lee, a Virginian, was only twenty years old in 1776 when he organized a band of cavalry and was made a captain in a regiment of light dragoons. The regiment joined Washington in Pennsylvania, where the dashing young officer led his cavalry on a series of daring raids on the British. Washington promoted him to major and authorized him to lead two troops of cavalry, known as Lee's Partisan Corps. By 1799, Washington's army was in Bergen County at New Bridge (River Edge). Lee organized and led a long march and raid on the British fort at Paulus Hook (now in Liberty Park in Jersey City). Lee's troops inflicted 50 casualties and captured 158 enemy soldiers. He was awarded a congressional medal for this exploit. After his brief stay at the Ryerson House, Lee was ordered to Virginia, where he led what one writer, Craig Mitchell, characterized as "one of the great cavalry units in the history of warfare."

Dirck Ryerson's house stood on Wagaraw Road about two hundred feet south of Lincoln Avenue. The main wing was typical of the Federal period in its center-hall floor plan, evenly cut and coursed stonework on the front wall and architectural details. Thus, it was probably built by John D. Ryerson, Dirck Ryerson's elder son, who inherited the western half of his father's property when he became twenty-one in 1782.

John Ryerson willed his homestead to his daughter Ellen Doughty in 1839. The will read, "Beginning at an apple tree on the south side of the bridge near the mill" and bounded on the south by the Passaic River, on the east by a millpond and brook (later known as Alyea's pond and brook) and on the west by land of his cousin, John G. Ryerson and others. This tells us that both a gristmill and a bridge at today's Maple Avenue existed at least as early as 1835, when the will was drawn. Kathryn Dubois, in her "Old Mills of Bergen County," says that the mill was known as the Hopper Mill

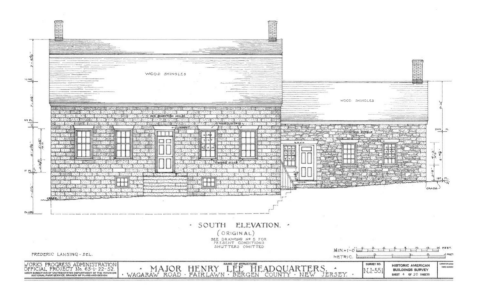

Drawing of the Dirck Ryerson House/Major Henry Lee Headquarters before modern additions. *From the Historic American Buildings Survey.*

and was the site of the murder of Titus Hopper during the Revolutionary War. However, there is no "Titus Hopper" in Maria Hopper's exhaustive compilation of Hopper descendants and unrelated Hoppers.

Ellen Doughty's widower sold the house and about ninety-six acres of land to Albert P. Alyea in 1842. His heirs conveyed the house and a large part of the property to his son-in-law, Peter Outwater, but Alyea families still owned about fifty acres and the gristmill in 1876. The homestead remained in the Outwater family until 1925, but starting about 1900, the former Ryerson land was gradually sold off to developers for housing and for the Wagaraw Bleachery. The house became vacant in the 1950s and was burned to the ground, probably by mischief makers, in February 1957. It is now the site of a building for personal storage units.

# THE HOPPER-STREHL HOUSE

Peter H. Hopper secured a tract of over 200 acres at "Small Lots" and built a one-room stone house in 1766 on the old Indian trail that became Fair Lawn

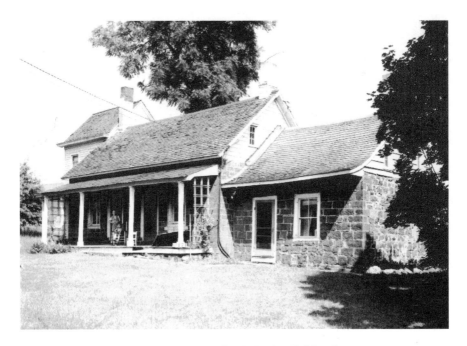

The Hopper-Strehl House, 1937. *From the Historic American Buildings Survey.*

Avenue. The house is shown but not named on one of Erskine's maps; it stood east of today's Craig Road. Hopper was one of the numerous Bergen County descendants of the original settler, Andries Hoppe, who came to New Amsterdam about 1651. (The final "r" was added to the name later.) Peter Hopper married Anna Doremus about 1769 and had five children. He built a large, five-room stone and frame addition to the house about 1780. His three sons each inherited parts of his lands in Fair Lawn. The oldest son, Garret P., was given the house and 107 acres of land, and Andrew P. inherited the adjacent 107 acres. Andrew was a captain in the Bergen militia in the War of 1812 and was later elected sheriff of Bergen County, a freeholder and an assemblyman. Henry P. inherited a "farm and premises at Small Lots which I lately purchased (120 acres)."

The executors of Garret's will sold the house and property of about 110 acres to S. Pope in 1852; Henry Strehl from Bavaria bought it about 1862 and added a two-story frame wing in 1887. The land was divided between Henry's heirs, John and Philip Strehl, with John retaining the house. John sold the property to the City Housing Corporation, the builders of Radburn. The Strehl family then established a drugstore with a pharmacy, liquor

department and "soda fountain" in the Radburn Plaza Building. The house was eventually sold to a developer and was demolished about 1962 to be replaced by a new house and doctor's office.

# THE DOREMUS HOUSES

John Doremus bought several hundred acres in Saddle River Township near today's Broadway in 1740 and was probably the builder of the Doremus house that once stood on Saddle River Road near the current southern border of Fair Lawn. A photograph taken in 1925 shows it to be a small, one- or two-room stone house of the style built about the mid-eighteenth century. John Doremus was taken prisoner by the British during the Revolution and was imprisoned in the infamous Sugar House. He died, of disease contracted in the prison, in 1784, soon after his release. John's son, Joris or George, settled on 225 acres of land north of Garretson's Lane (Broadway) at Saddle River Road and in 1805 built a large stone house facing the road.

Joris had five sons and a daughter. His oldest son moved to Old Bridge, but the others stayed on the land at Red Mills, as the area was then known. Joris left his house and 145 acres of farmland to his son John B. His second son, Albert, was a stagecoach driver, and his third son, George, was a farmer and keeper of the Hamburgh Hotel on 114 acres on Saddle River Road, north of his father's farm. His youngest son, Peter, was a blacksmith at Red Mills and may have lived at the original Doremus House.

The original house disappeared between 1925 and 1936. The Joris Doremus House and farm passed to his grandson, who sold it and the remaining twenty-five acres to William Ackerman. In 1928, it was sold to the City Housing Corporation for a planned entrance to Radburn along Route 208. The state purchased it and tore it down to make way for an interchange at Routes 4 and 208 and Saddle River Road in the 1960s.

# THE HOPPER-CROUCHER FARMSTEAD

Henry A. Hopper, son of Andrew P. Hopper of the Hopper-Strehl House, built an imposing Italianate house on his farm on Small Lots Road in 1855. The farm extended from Fair Lawn Avenue almost to the Glen Rock line, and Hopper owned another farm east of his home. The house stood near

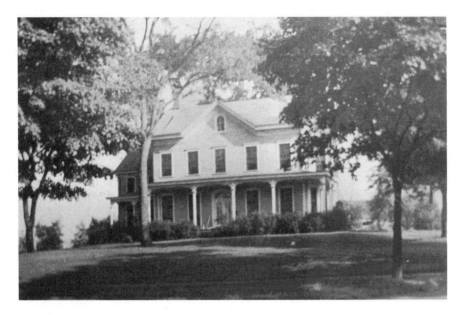

The Hopper-Croucher House. *Courtesy of the Cadmus House Museum.*

the road, where Route 208 intersects today. Henry Hopper, like his father, was interested in governmental affairs and served successively as Bergen County sheriff, freeholder and representative to the state legislature, as well as township committeeman. His farm was known as one of the finest in the county, and he was known as "the Melon King" for his vast expanse of melons. The east wing and part of the main house burned down in 1890, apparently catching fire while lard from slaughtered pigs was being rendered on the farm. Hopper rebuilt the main block but constructed a new wing to the west of the house

Hopper died in 1912 at the age of ninety-three. His heirs sold the house and the adjacent farm in 1919 to William Croucher. Croucher was one of the first councilmen when the borough was formed in 1924. In 1952, Croucher's three sons sold the house and farm to the Fair Lawn Development Company for the development of the McBride industrial park. The house was used for offices for many years until it was demolished in 1989 by the state to make way for an improved interchange at Route 208. The state conducted an archaeological dig of the site and gave the artifacts recovered to the borough. These are now in the Cadmus House Museum, where they may be studied by those interested in nineteenth-century life.

# THE ADAM HOPPER HOUSE

Adam Hopper was born in 1847 in a house that stood on the west side of River Road, near where Hopper Avenue crosses today. He was the son of John A. Hopper and Mary Ellen Alyea and great-grandson of Peter A. Hopper, who built the Hopper-Strehl House. Adam Hopper inherited land east of River Road from his father and built a house facing Fair Lawn Avenue (near Eleventh Street) for his bride about 1875. The two-and-a-half-story frame house was similar in style to the second version of the Henry Hopper House but had tall bay windows in front and a large wing in the rear. Adam Hopper was, at the time of his death in 1939, Fair Lawn's oldest resident.

At this time, Police Chief Michael Vanore encouraged Henry "Pop" Milnes and his wife Esther to start a Boys' Club. The borough bought the Adam Hopper House for the club; it and its barn served the boys of Fair Lawn for many years. When Pop Milnes died in 1950, the Boys' Club buildings were closed. The Adam Hopper House was torn down years later and replaced with a new residence.

# SAVED: THE THOMAS CADMUS HOUSE

Thomas Cadmus owned a large farm fronting on Small Lots Road and extending into Glen Rock when, in 1816, he bought the adjacent two-room stone house and three acres of land from Abraham and Harmonus Vanderbeck. The Vanderbecks had bought the property a year earlier from Jacob Haring, who evidently was the builder of the house. Kevin Wright, in a 1996 document, traced the building of the house to between 1808 and 1815. He surmised that Haring built the home shortly after his 1808 marriage to Margaret Van Bussen. The house has long been known as the Cadmus House because earlier research could not determine whether the house was built by Cadmus on the land he owned earlier or whether it stood on the land he bought from Haring.

Thomas Cadmus was a descendant of Thomas Fredericksen, a Dane who came to the town of Bergen, New Jersey, in 1661 via Holland and New Amsterdam. The family later took the name of Cadmus, but the origin of the name has not been discovered. Thomas Cadmus's forebears bought land in the southern part of the Sloterdam Patent (now Garfield

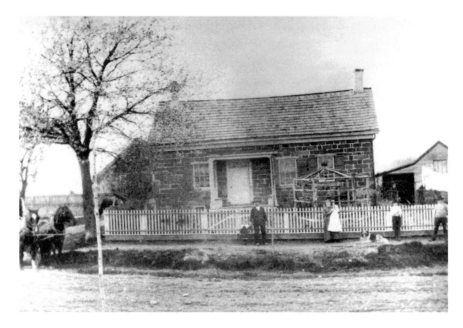

The Cadmus House before modern additions. *Courtesy of the Cadmus House Museum.*

and Elmwood Park), and Thomas lived there before settling on Small Lots Road. He inherited land from his father, Abraham, in 1804; this may have included the long, narrow, eighty-eight-acre farm that Thomas owned when he bought the house. He married Margrietje Doremus and they had twelve children. William Cadmus, who had a house on Berdan Avenue in 1876, was probably a descendant.

Cadmus and his wife sold the house and the ninety-two-acre farm in 1831 to Henry P. Hopper, whose father built the Hopper-Strehl House. The property changed hands several more times; one of the owners added a frame kitchen to the back of the house. In the 1920s, a gambrel roof with dormer windows was added, and the building was rented out for commercial uses. The builders of Radburn had offices there when the "new town" was being built.

By 1979, the house and one acre of property were owned by Richard and Marleen Grabowski, who used it for their store, Bedlam Brass Beds. The building was placed on the State Register of Historic Places in 1980 and on the National Register in 1983. In that year, the Grabowskis filed a plan to replace the house with an office building and parking lot, setting off an effort by concerned citizens and the borough to save the house. The

Grabowskis promised to delay demolition of the building as long as possible, and the borough council arranged to take title to the building and to lease a nearby railroad property site from New Jersey Transit. Fundraisers were held, and Fair Lawn resident and assemblyman Nick Felice secured a grant from the state for the moving costs. In January 1985, the stone building was moved several hundred feet to its new home. A volunteer group was incorporated to run the building as a municipal historical museum. This old house was not lost.

Many other historic buildings have been lost to redevelopment, including David Acker's "Fair Lawn" for which the borough was named, the early stone house on Acker's property and George Morlot's Bellaire. These stories appear in other chapters.

# An Indigenous Architecture

As late as 1950, Fair Lawn had ten early stone houses in the Dutch Colonial style and was reputedly home to more pre-Revolutionary houses than any other town in Bergen County. Today, three pre-Revolutionary homes, three other early stone houses and a frame house remain to illustrate the building style of our forebears. All except the frame house are on the State and National Registers of Historic Places.

When a settler arrived on his newly purchased land, there was no time to build a stone house, so the first homes were of sapling framework covered with bark or even a room dug into the side of a hill and roofed with sod. Later, a small house of wood or rough stone accommodated the family. Almost all of these first houses are lost; many of the surviving homes are not the first built on the property. However, if a family was relocating to a new farm from a nearby town, as, for instance, the Vanderbecks to Dunkerhook, a substantial house could be the first one constructed.

The early settlers of northeastern New Jersey and adjacent New York developed a unique style of architecture commonly known as Dutch Colonial. In Bergen County and other places where stone was available, the homes were built of the red sandstone familiar in most of Fair Lawn's remaining early houses. The homes, except in Manhattan, were all one story in height, with a basement and a livable attic accessed by a ladder or steep stairway. The attic had windows at each gable end—but no dormers—and was used for slaves' or children's sleeping quarters and for storage. The houses faced south to get the most heat from the sun and often had no windows on the

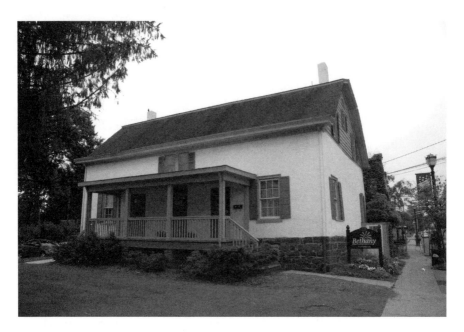

The Garret V.H. Berdan House. *Photo by Ron Lotterman.*

north side. All of the early homes on Small Lots Road (Fair Lawn Avenue) were on the north side of the road so that the front of the south-facing house would be on the street. The Garret V.H. Berdan House on River Road has its end to the road; it too faced south.

Other features of these homes were gable or gambrel roofs with shingle or clapboard gable ends; exposed, often hand-hewn beams supporting the attic; wide board floors; split Dutch doors (so that the upper door could be opened to the air but the animals could not get into the house); and a large fireplace for cooking, often with an oval beehive oven at the rear. The Garretson House has a reconstructed beehive oven, and there is evidence that there was one in the smokehouse on the original Vanderbeck property. The smokehouse is today owned by a bank but has been preserved.

The construction of the thick stone walls of the homes depended on slave labor to quarry, cut and lay the stone. Slavery was common and was encouraged by both the Dutch and later the English proprietors in order to increase the labor supply of the sparsely settled land. A bounty of land was actually offered for each slave brought into the county. The red sandstone was plentiful in most of the county and was often quarried on the farmer's property. In the earliest homes, the stones had irregular shapes and were

laid in rough rows or courses, with chips and smaller pieces used to fill in the gaps. Later, the front wall of the house was made of stones carefully squared off and laid in even courses, but the side walls were still roughly built. Most of Fair Lawn's extant stone houses follow this pattern of masonry.

The Dutch Colonial style evolved slowly from that of the steep-roofed homes of the earliest settlers. The pitch of the roofs was lowered and the eaves were extended over the front and rear walls to protect from rain and snow not only the foundation but also the clay and straw mortar used between the stones. The lower edge of the roof was usually turned upward at the eaves in a graceful curve or "kick" so that it did not impinge on the windows and doors. This feature appeared only in northern New Jersey and southern New York homes. Some architectural historians believe that the curved eave originated in either France or Flanders; thus, the style is sometimes called Flemish Colonial. The pre-Revolutionary one-room wings of the now-demolished Hopper-Strehl and Dirck Ryerson Houses both had curved eaves.

By the early 1700s, gambrel roofs with two slopes began to appear in what is today Bergen County. Gambrel roofs were used mostly on the wider houses of two rooms deep. The Dutch gambrel was more graceful than that of New England, having a short, rather flat upper slope and a long, lower slope, usually ending in a curved overhang. This roof gave more room in the attic than a single-slope gable roof. In Fair Lawn, the G.V.H. Berdan House on River Road and the old wing of the Jacob Vanderbeck House off Dunkerhook Road are remaining examples of gambrel roofs with upswept eaves. Both the Cadmus and the Garretson Houses have Dutch gambrel roofs, but they are later additions, built when the dormers were added in the early 1900s.

The earliest homes were only one room about twenty feet square with a basement and attic and a cooking fireplace. The room was truly a "family room" where the household cooked, ate and worked. There was usually a curtained-off bed on the first floor for the parents and cots in the attic for the children. Additions were made later as the family grew and prospered. Often, a stone addition of two or more rooms was built at one side of the first home. Additions to the rear of the house, customarily of frame construction, were made only after 1840. Both the Hopper-Strehl and the Dirck Ryerson Houses started as one-room homes.

A house type often built in Fair Lawn was the two-room house with a fireplace at each end and an entrance door for each of the equal-sized rooms. The Richard J. Berdan House, now the Dutch House bar and grill,

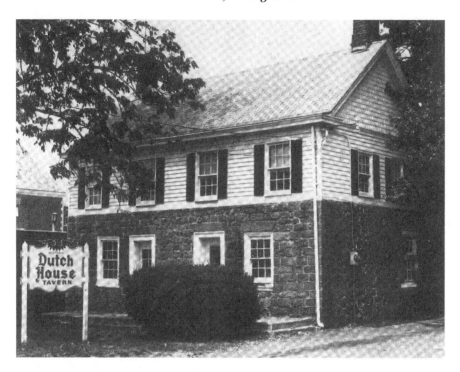

The Richard J. Berdan House, showing two front doors. The upper story is a later addition. *Author's collection.*

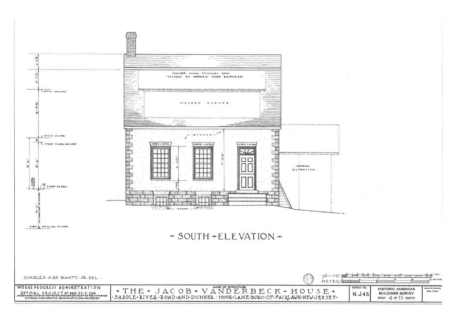

Drawing of the Jacob Vanderbeck House before modern additions. *From the Historic American Buildings Survey.*

was built on this plan and retains its two doors. The Thomas Cadmus House, now the borough museum, is another example, but as was often the case one door was later made into a window. Both of these houses had later rear additions of frame construction used for kitchens and, more recently, raised roofs to provide for second-floor living space. The main floor of the Vanderbeck-Naugle House has one large room and a smaller room, a common variant of the two-room plan, with the smaller room having no fireplace. This house also has a later upstairs addition, but one of only a half story, made in the early 1800s with small, low windows known as knee-high or eyebrow windows.

After the Revolutionary War ended and the local economy recovered, prosperous farmers started to add newly fashionable features to their stone homes. Although developed from English stylebooks, the new architecture is known as the Federal style since it came into use in the United States during the first period of our independence. Most houses were still built of stone but were often larger, being two rooms deep, and often had a center hall so that the rear bedrooms did not open directly from the living areas. These homes featured decorative elements from classical Roman times such as medallions, garlands and urns. They also had a window over the front door and sometimes side lights as well. In Bergen County, these elements were simply added to new or existing stone houses of the Colonial style, although new homes had walls of stone with a smoother surface or a stucco finish.

A Fair Lawn example of Federal architecture is the old wing of the Jacob Vanderbeck House, built in the late 1700s. The sandstone walls are regularly coursed and the front wall has a stucco finish with stone corner quoins. There is a rectangular window over the front door with panes in the fan-like pattern typical of this period. The Historic American Buildings Survey drawings of the original floor plan show a side hall giving access to the living room and one bedroom, with another bedroom off the main room. The drawings of the fireplace show fluted pilasters and a mantel decorated with round and oval fluted medallions.

The only early frame building remaining in Fair Lawn is the Hopper-Milnes House, probably built in the 1820s. This home is typical of those described as being the prevalent local style of the Greek Revival period in *The Architecture of Bergen County, New Jersey* (Brown and Warmflash): a one-and-a-half-story home consisting of a main block of three bays or openings (doors and windows) and a smaller wing of two bays. The upper story is low, with knee-high windows, and there was an entrance porch with square

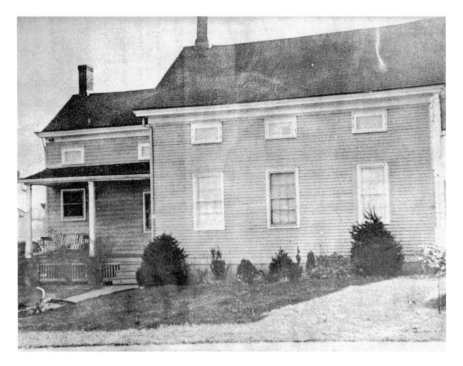

The Hopper-Milnes House. *Photo by Paul Rosenberg in* From Slooterdam to Fair Lawn.

columns typical of the style. This home stood near the Dutch House on Fair Lawn Avenue but was moved one block south to Warren Road to make room for modern development. The original columns have been replaced with others, and the front wall of the smaller wing has been faced with brick, but the characteristic low windows remain.

# A House in the Country:
# How Fair Lawn Was Named

In 1857, David Depeyster Acker of New York City bought a sizable farm fronting on Small Lots Road (Fair Lawn Avenue) in Saddle River Township. Acker was born near Fair Lawn in 1822. His grandfather, David Acker, had come from Holland before the Revolution and was a farmer in Bergen County. His father, David Ackerson, died when the son was only eight years old. David D. Acker left Bergen County for New York City and became a successful businessman. He made his fortune in the grocery trade, and by 1860, at the age of thirty-eight (as the census for that year tells us), he had a substantial house in the city. This property housed not only his family of ten but also six Irish servants and nine men, including clerks, a collector and a cattle broker who were all apparently employees of his business.

Acker hired a local carpenter, John G. Hopper, to build a commodious frame house in the latest style on his farm—a house in the country. Sometime between 1862 (when records show him living at 132 Chamber Street in New York) and 1864, Acker moved his family to his property in Fair Lawn. His relocation was the first instance in the area of today's Fair Lawn of a wealthy businessman moving out of the city to live amid the farms of the countryside. Sadly, his wife, Eleanor Marie, had little time to enjoy her new home. She died at the house in June 1864, and Acker sent carriages to the Paterson depot to meet the mourners who came by train from New York.

Acker's large, then-modern home in the Italianate style stood at the top of the hill on Eleventh Street where the Senior Center is now. From the

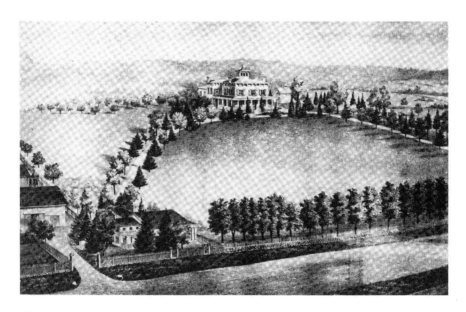

View of the Acker Estate, Fair Lawn. *Courtesy of the Cadmus House Museum.*

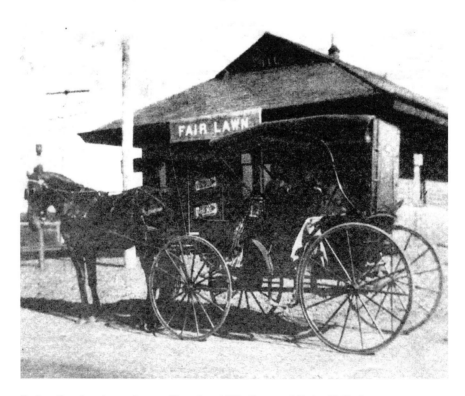

Early railroad station and post office, circa 1895. *Courtesy of Evelyn McHugh.*

cupola atop the house, which was located at the highest point in town, the view of the surrounding countryside was impressive. An early stone house in the Dutch style, known as the Van Houten House, stood near the road (where the library is today). This dwelling was used by some of the farmhands. The barns were behind this house. The Saddle River Township District No. 43 Schoolhouse was located at the edge of the property. The census for 1870 recorded the real estate value as $20,000 and Acker's personal estate value as $100,000, ten to fifty times that of his neighbors.

Following the latest fashion in landscaping, Mr. Acker had created a broad "lawn," sweeping down the hill from his house to the road. Sheep grazed the lawn to keep it closely cropped. A long, tree-lined semicircular carriage drive bordering the lawn led up to the house. David Acker was evidently so proud of his expanse of green that he named his estate "Fair Lawn."

When the railroad was built through the town in 1881, Acker had a shelter erected next to the tracks on Small Lots Road. Here, his guests from the city could wait for his carriage to take them to his home. On the shelter he put a sign, "Fair Lawn." Later, the railroad built a station house at this location and called it the Fair Lawn station to distinguish it from the station at Warren Point. Eventually, Small Lots Road became known as Fair Lawn Avenue, and the Small Lots area was called the Fair Lawn section of the township. The mansion and the farm remained in the Acker family until 1921.

When the people of what is now our borough decided to separate from Saddle River Township, they chose Fair Lawn for their town's name. Because of a clerical error in the legislation creating the borough in 1924, the name was legally "Fairlawn" for a short time. The borough fathers quickly petitioned the legislature to correct the error, and our town is Fair Lawn today.

In 1927, the mayor and council voted to buy the Acker homestead for use as the municipal building. The borough offices and later the police department and the public library moved to the building. Thus, for many decades Fair Lawn's government was housed in the home for which it was named. After a new Borough Hall was built in 1960, however, the building was allowed to deteriorate. Despite pleas to save the landmark, the council deemed it too expensive to restore, and it was demolished in 1967. The site is now the home of the borough's modern and popular Senior Center. The early stone house on the property was also demolished to become the site of the new library, which opened in 1967.

# The Mystery of George Morlot

George Morlot was a prosperous silk dyer who built himself an elaborate Victorian-style mansion in what is now Fair Lawn. Much is known about his life, but his death remains a mystery. There have lately been tales that he jumped or fell into the Passaic River. Another story says that one of his friends received a letter from Morlot from Cuba ten years after he disappeared. But newspaper accounts of the time tell a different mystery story.

Morlot was born in 1836 in Lyons, France, a city that had already been a silk-weaving center for three hundred years. Morlot started in the silk business at the age of seventeen after studying chemistry and mathematics at the university in Lyons. At twenty-one, he was appointed superintendent of a Lyons dye works, where he worked for many years until he departed for New York City in 1863. In 1865, he started his own business on Third Avenue in that city.

He moved to Paterson in 1869 and the next year established a partnership with Jacob Stettheimer. They built the Morlot and Stettheimer Dye Works on land in Paterson that extended from Tenth Avenue to the Passaic River between East Thirty-second and East Thirty-third Streets. Records from 1872 through 1893 show that Morlot was the sole owner of the firm. The business prospered because of the purity of the property's well water, which was important in light-color dyeing. Several large silk manufacturers became customers of the firm. The dye works expanded over the years and by the early 1890s employed more than two hundred men.

The George
Morlot mansion.
*Photo by Paul
Rosenberg in* From
Slooterdam to
Fair Lawn.

Sometime after establishing his business, George Morlot built his twenty-four-room mansion and stables just across the Passaic River from his factory. The grand, three-story house was in the Victorian style, having many bay windows, several dormers, a captain's walk at the top of the roof and a three-story tower at one end. He called his estate Bellaire, but the road on which his home faced became known as Morlot Avenue. Morlot was known as a genial man and was married, but we know little else about him.

On the morning of Saturday, March 3, 1894, George Morlot boarded a train for New York City after having drawn almost $4,000 from his Paterson bank to pay wages. He had not told his wife that he was going to New York. According to newspaper reports at the time, he was carrying a large parcel and appeared nervous. He spoke to his seatmate, fellow Paterson industrialist Samuel Newman, only to ask for a piece of string to tie his parcel. Newman told the press later that he looked for Morlot after leaving the train at the end of the line, but he had disappeared "as if the ground had opened and swallowed him up." His wife offered a reward of $100 for information leading to his recovery but George Morlot was never seen again.

When the silk dyers reported to the factory office for their wages, they were told that Morlot had not returned and to come back on Monday. As reported by the *New York Times*, when the men assembled on Monday morning they "became boisterous when told that Mr. Morlot was still missing."

The *Paterson Evening News* at the time theorized that he may have been killed for whatever money he carried. Another possibility, noted by Paterson historian Vincent Waraske, is that, since workers were striking at the time over low wages and poor working conditions, Morlot may have been killed by disgruntled strikers. Waraske theorized that he could have been killed near the train station or on the train and thrown off, although he "was a big heavy man." However, the *New York Times* article of March 18, 1894, concerning the reward noted that "he is known to have been in Chicago on March 6."

The mystery of George Morlot's disappearance was never solved, although investigations were conducted on both sides of the Hudson River. His mills were later occupied by other companies, and in 2009, one of the buildings became a restaurant. His mansion was bought by Ernest Formann, who planned to build homes on the adjacent property but did not. He sold the ten-acre property to Daniel Hymes in 1929. Later, after being vacant for a long period, the house was refurbished as the private Hamlin School. In 1964, the buildings were torn down to make room for

a housing development. Today, the former estate is occupied by homes on a new street called Hamlin Court, and only Morlot and Bellair Avenues remain to recall it. But the disappearance of George Morlot remains one of the most famous unsolved mysteries in the city of Paterson.

# History in Street Names

H ow did Fair Lawn's streets get their names? Today, the borough council has the power to dedicate land for streets and also the power to name them. Early in the history of the area, the county government had this power. But where did the names come from? And what can we learn from the sources of those names?

The oldest roads acquired their names informally from local usage. Roads were named for geographic features or landmarks. River Road (originally an Indian trail) was called Sloterdam Road at the time of the earliest colonists, after the Dutch name for the Native American fish traps in the Passaic River. The name of the road went through various spellings, including Slooterdam and Slotterdam, before becoming River Road. Wagaraw Road took its name from the Lenape natives' name for the area at the "great bend" of the Passaic River. Garretson's Lane, now Broadway, led from the hamlet of Zabriskie's Mills at Paramus Road to Peter Garretson's farmhouse on River Road and the White Horse Ford over the Passaic River. The early bridge over the Saddle River has been replaced by another in the same location, now called Red Mill Road from a later name for the neighborhood at the mill, Red Mills.

What is today Maple Avenue ran from the Wagaraw Bridge connecting to River Street in Paterson to New Prospect (Hohokus). In the 1850s, the road was a stagecoach route known as the New Prospect–Paterson Turnpike; it was shown on 1896 and 1913 maps as the Paterson & Ridgewood Road. These roads are shown (but not named) on a map made by the surveyor

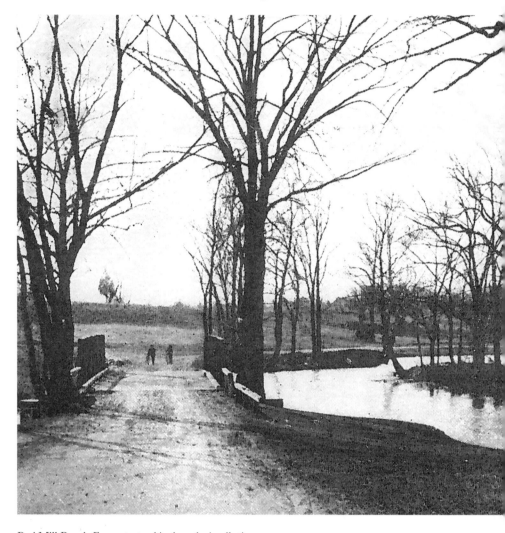

Red Mill Road. *From a postcard in the author's collection.*

Robert Erskine for "His Excellency General Washington" during the Revolutionary War.

Saddle River Road was known as Swamp Road in Revolutionary times and as late as 1909 because of the swampland along the river. Tory raiders used the "great thicket" along Swamp Road as a hiding place from which to mount their sorties on neighboring farms. Garretson's Lane was apparently the scene of a skirmish during the war, as recorded by John A. Ackerman in a diary excerpted by Willard L. De Yoe in his *Revolutionary Days in Paramus.*

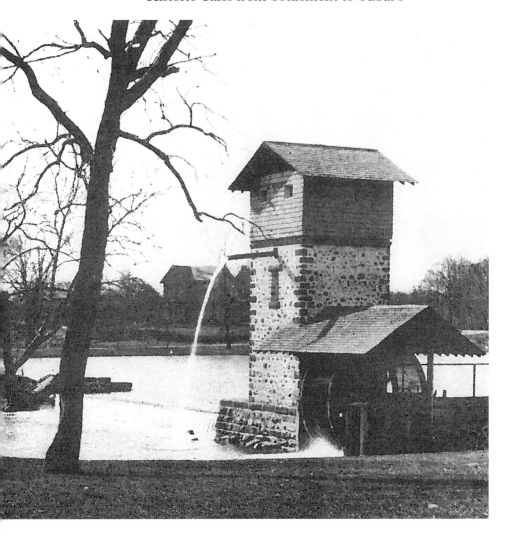

*May 14, 1777—(The militia) met the Tories on the road from Hackensack to Paramus at Saddle River below Zabriskie's Mill. The overwhelming force of the enemy caused them to retreat. At the mill they took the road to the ford over the Passaic River at Slooterdam. As the water of the river was too deep, escape was prevented and a bitter hand-to-hand encounter occurred on the road near the ford. When the militia no longer had time to load their muskets, they used their bayonets. Captain Marinus and several others were captured but the others made their escape.*

Fair Lawn area in 1861. Small Lots Road is at the top. *Courtesy of Allen Lutins, from map by G.M. Hopkins.*

Dunkerhook Road retains its original Dutch name (*Donckere Hoek*), meaning "dark corner." This old road was documented in a "road return" or survey by Bergen County in 1767. Another early road, Small Lots Road (now Fair Lawn Avenue), was established in 1770 by the surveyors of the highways, "being Duly Summoned by Som of the Inhabitants of Slaterdam" to serve the "small lots" north of the road. These lots were narrow but long, extending into today's Glen Rock. The road was surveyed on the boundary between the "great lots" and the small lots that had been laid out late in the seventeenth century by the proprietors of the Sloterdam Patent. One source (Rogers) tells us that this boundary was a Native American trail that ran from a ford in the Passaic River to the Saddle River. There are other early patents that were bounded by Indian trails, so this claim seems plausible.

The 1770 road turned north at Prospect Avenue and continued along it to the current Ridgewood border. Prospect Avenue (for "broad view") started at the high point of Small Lots Road. By 1861, Small Lots Road was extended to Swamp Road, as shown on a map made by G.M. Hopkins.

A few new streets were added to these original roads during the 1800s. Old maps and atlases give us some information. Cherry Lane, now Lincoln Avenue, was established by 1825. It ran north from Wagaraw to the west side of Ridgewood, and the Fair Lawn and Glen Rock sections of it became a part of the boundary between Bergen and Passaic Counties. Berdan Avenue appears on the 1876 Walker atlas, which shows every building and its owner's name. This street was established to serve several Berdan family farmsteads and the home of William Cadmus, but the eastern part of it was still a dirt road in the mid-1930s. Midland Avenue, which extended south from Broadway, ran midway between the Passaic and Saddle Rivers. Harristown Road also appears in the Walker atlas.

Part of Morlot Avenue (unnamed) was shown on 1867 and 1872 maps as part of an ambitious but unrealized development east of River Road, called Rochedale. The road does not appear on later maps until 1909. The name came from George Morlot, who built his mansion, Bellaire, near the Passaic River on land between today's Morlot and Bellair Avenues.

## The First Suburbs

By the end of the nineteenth century, the Fair Lawn area was starting to change from a strictly farm community to a suburb. Developers laid out streets and subdivided the land into small lots for homes for the workers in Paterson silk mills and Fair Lawn dye and bleach works. At this time, the developers chose the names for the new streets. The most successful housing developments were those near the employment centers and the train and trolley routes.

One of the earliest subdivisions built was laid out in 1892, west of River Road, by the Fairlawn Land Improvement Association. This is the first appearance of Hopper Avenue. The name may be from the previous owners, John A. Hopper and his descendants, although one source (Rogers) says that the street was named in honor of Andrew Hopper, a leader of the Bergen militia during the War of 1812. The cross streets were First through Sixth, but in reverse order as today. The subdivision map shows River Road as "Slaughterdam Road," a corruption of the earlier "Sloterdam," and Fair

Lawn Avenue was called "Boulevard." This area was known as "the Flats," referring to the expanse of low-lying, level land on which the homes were built. The great flood of 1903 inundated part of this area and destroyed the Fair Lawn Avenue Bridge connecting to Paterson. By 1913, there were fifty homes, a hotel, a factory and the Kuiken family woodworking shop. In 1912, the Kuiken brothers formed a construction company and built some of the homes in this development. The Kuiken firm is the oldest continually operating business in Fair Lawn.

W.A. DeMuth filed a map in 1873 for land west of River Road. He planned Bergen and Passaic Avenues, named for the two counties, and called Fair Lawn Avenue "DeMuth Avenue" after himself. Most of the lots were never developed, but Bergen Avenue remains. The old one-room schoolhouse was moved there from Fair Lawn Avenue in the late 1870s and was subsequently known as the Bergen Avenue School as well as the Washington School.

Another early development was at Riverview Terrace, started in 1899, along Lincoln, Columbus and Heights (originally Bergen) Avenues, the latter renamed in 1924 for its location uphill from Lincoln Avenue. This subdivision had forty homes by 1913, and the section was later called Columbia Heights.

In 1903, the first house in the Grunauer subdivision in the Warren Point section was sold at what is today 3-09 Grunauer Place. These homes were well placed at Broadway near the railroad station and the trolley line. Following the custom of the day, the Grunauers named the other streets, Rosalie and Raphael, after themselves. There were twenty-four homes here by 1921, when the Broadway Development Company filed plans to extend Rosalie and Raphael Streets eastward from Twenty-fifth to Thirtieth Street.

Part of the Van Riper farm at Morlot and Berdan Avenues was subdivided early in the twentieth century. The tract included Bellair Avenue and Ellis Avenue, named for Ida Van Riper Ellis, who had founded the Union Sunday School nearby. The rest of the farm was laid out in residential blocks in 1924 and was developed through the 1930s and 1940s. The cross streets were all numbered rather than named.

Martin Romaine was a descendant of an old Saddle River Township family. He planned a housing development on part of his farm along Berdan Avenue both east and west of the railroad in a map filed in 1891 as "Pleasant Cottage Sites." By 1924, only a few houses had been built, all west of the railroad. A later extension of this development east of Plaza Road was called Spellman City. John Spellman had property adjacent to Romaine's. In addition to Romaine Street, the development included Kipp Street,

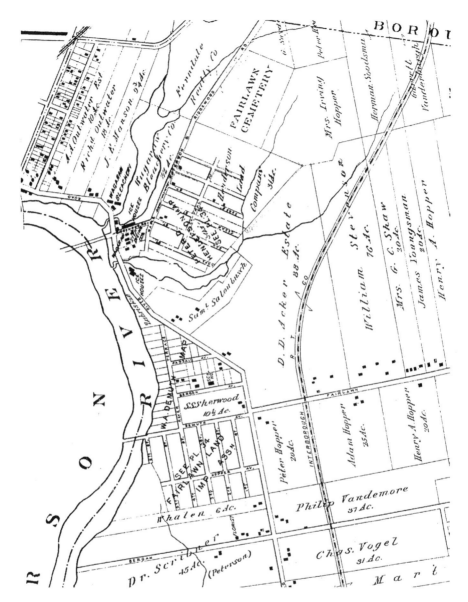

Section of Fair Lawn area in 1913 showing subdivision maps. *From* Atlas of Bergen County, N.J., *by G.W. and W.S. Bromley.*

Cadmus Place and Fairclough Place. John Kipp was a young farmer living on Sloterdam Road near Berdan Avenue in the 1870s. He or a descendant may have owned a part of the property or he may have been a business partner. Cadmus Place was named after the Cadmus family, who owned a

house on the western part of the property as early as 1876. The house was later moved from Berdan Avenue to Kipp Street. Fairclough Place was also named after another old Fair Lawn family.

Peter D. Henderson Jr. laid out a subdivision on his farm in 1912. He named Henderson Boulevard for himself; Chester Street may have been named for a family member. Lake Street was adjacent to Henderson's ice pond. Central Avenue ran down the middle of the property. Other streets were named for woodland greenery: Oak, Cedar, Forest, Fern, Myrtle and Maple. The last (now Weber Place) was a short street connecting Lake Street to the Paterson and Ridgewood Road—now called Maple Avenue.

## THE CHANGING 1920s

Building activity picked up in the 1920s, when many farms were turned into housing developments. In 1923, Thomas Lynch started building Lyncrest Manor at Broadway in the Warren Point section. Lynch named the development and its main street after himself. Cyril and Kenneth Avenues were probably family names, and Summit was at a high point in the landscape. The cross streets—Magnolia, Willow and Columbia—were extensions of these streets in the adjacent Elmwood Park (then East Paterson). Magnolia Street was later changed to St. Anne Street after the church was built there.

Starting about 1924, two of the Kuiken brothers, Nick and Richard, built many homes on Peter Hopper's farm east of River Road. Nick's brother-in-law, Dick Vander May, had bought the farm, Nick handled the business end and Richard was in charge of the building. Hopper Avenue was extended through the property, and Edward and George Streets were named for Kuiken family members. Across Fair Lawn Avenue, on part of the former Acker Estate, the Fair Lawn Development Company extended George Street and Bergen Avenue and laid out Campbell and Raymond Streets. The Kuikens built houses here too. Raymond was a family member, and we can guess that Campbell was the developer or a partner.

Also in the 1920s, Andrew De Boer developed new streets adjacent to Heights Avenue in the area known as Columbia (originally Columbus) Heights. Albert Avenue was named for Albert Outwater, who had previously owned this part of the development; Katherine Avenue was for Katherine Kalft, whose family had owned part of the property; and Pomona Avenue was named after the section of Jersey City where Andrew De Boer got his

start in business. Smith Avenue, laid out in 1924, was undoubtedly in honor of Fair Lawn's first mayor, Robert Smith. Lakeside Avenue led to Alyea's Pond, which extended along Smith Street.

Several subdivisions filed with the county early in the century were not built until much later, but the street names were kept when building commenced. The streets of Floral Gardens were laid out about 1920, but the homes were built later, starting in 1924. The streets included Floral Avenue, Orchard Street and Rose Place. Burbank Street was apparently named for Luther Burbank, who was renowned at that time as a horticulturist who bred numerous varieties of fruits and flowers. Arnold Street was included in this subdivision. It was named for Arnold Dater, who built the homes on this street.

Paterson Park East, at the east end of Morlot Avenue, was another early subdivision (1918) that was developed in sections much later, but the street names—Philip, Eugene, Karl, Dorothy, John, William and Elizabeth, probably chosen after family members—remain today. Pershing and Wilson took their names from our World War I general and president; Monroe was an early president; Union, Grant and Lincoln were Civil War names, although the latter was replaced by Brennan Court after Fair Lawn's longtime official physician. Paterson Street took its name from the proposed development. Some of the original twenty-foot lots of this development were bought by people from New York City who pitched tents on their properties in the hot summer months.

A map made for Fair Lawn's *Golden Anniversary Journal* shows the streets as they existed in 1924 at the borough's founding. Apparently, there was a move to rename all the streets and avenues with numbers, starting with First Street at the Passaic River and First Avenue at Broadway. Many of the north–south streets retain their numbers today, but the numbering of avenues and major streets like River Road was fortunately discontinued; thus, we can still find some history in the names.

Bellair Park, a 1922 development along the west end of Bellair Avenue, had land that extended west of First Street. These streets were designated as West A through West E but were later given names: Arnot, Bush, Canger (in honor of borough engineer and civic leader Michael A. Canger), Dewey and Essex.

The Fair Lawn Gardens development was built on part of the Peterson property along Berdan Avenue. This long, narrow tract, on which Peterson grew roses for florists, once extended to the railroad. The new street here was Rosewood Street. Later, this tract's section of Eleventh Street was changed

to Roosevelt Place as it gave access to (Theodore) Roosevelt School, now known as Forrest School.

Many people have been puzzled about the origin of Westmoreland Avenue. This street was a part of the Pearl Manor development started in 1924. The land ran along Henderson's Pond and across Henderson's Brook and included a slice of the Acker Estate; Westmoreland Avenue was laid out parallel to the estate's northern boundary. Westmorland (with no "e") is a county in Canada; Ontario Avenue was probably named after the lake or the province of Canada, so it seems that the developer was memorializing a former home. Kossuth Place may have been named after the Hungarian patriot and statesman who died in 1894. The other streets are extensions of roads in Henderson's development, although most were never actually extended across the pond. Because of the swampy conditions in this area, most of the lots were not developed until the pond was drained and returned to its original streambed. Part of the property became the site of a borough well field and water storage tank.

# THE COMING OF RADBURN

In 1929, the first families moved into their new homes on Allen Place in the new "Town for the Motor Age," Radburn. Radburn was the old English translation of Saddle River.

The main road into the new town extended from Twenty-fifth Street at Broadway and was called Plaza Road. The road ran between the Plaza Building, the imposing Georgian-style building housing shops and offices and a large open space, or plaza, that extended to the railroad and its new station. Two other main streets of the town, Howard and Owen Avenues, were named for early town planners. Ebenezer Howard was a leader in the Garden City movement and planned Letchworth and other new towns in Britain. Robert Owen was a British reformer who developed a plan for a utopian factory workers' community surrounded by farms and gardens. He and his son, Robert Dale Owen, came to the United States and built a town, New Harmony, based on his earlier plan. Warren Road may have been named after Whitney Warren, architect of the Grand Central Terminal in New York City. Sunnyside Drive, no longer part of Radburn, was probably named for Sunnyside Gardens, the noted housing project in New York planned by Stein and Wright, the planners of Radburn.

Cutting a new road. *Courtesy of the Cadmus House Museum.*

The "superblocks" formed by the main roads gave access to the cul-de-sacs surrounding the central parks. All the streets in the first superblock, known as "A Block," started with *A*, and in the second with *B*. The other blocks north of Fair Lawn Avenue were never built. Streets on the "South Side" of Radburn started with *R*, *S* and *T*, but most of the South Side was not built until the early 1940s. Most of Radburn's interior streets were named after British cities (Aberdeen, Bristol, Bolton and Reading, for example) or English and American notables, such as artists and statesmen. Among these, two names celebrate other early town planners. Daniel Burnham was a city planner, famous for starting the "City Beautiful" movement and for the exhortation to "Make no little plans—they have no magic to stir men's blood." John Ruskin was an English social reformer who wrote on the ugliness and poor living conditions of the city and called for improved housing and the integration of art and life.

This "history in street names" has traced Fair Lawn's development through the 1920s. Street names pay tribute to the builders of Fair Lawn—both those who built the houses and those who formed the borough and provided the governmental and volunteer services over the years. The sources of other street names and some notes on later housing developments can be found on the author's website, www.fairlawnhistory.com.

# The Birth of a Borough

At the end of May 1923, some of the residents of the Fair Lawn area were hopping mad. Their hope for new schools to serve the growing population had been dashed in a school referendum that proposed five new school buildings for Saddle River Township, of which Fair Lawn was then a part. The only school approved for their area was an eight-room building on Hopper Avenue (called the Roosevelt School in honor of Theodore Roosevelt and later changed to Forrest School to honor a revered principal). The only other schools in our town were the 1853 wooden Bergen Avenue School, which had only three rooms, and the four-room brick Warren Point School, built in 1921 to replace the two-room 1898 wooden building. Students in the Columbia Heights area had to go to neighboring Hawthorne in Passaic County, and a school proposed for their neighborhood had been voted down.

Many Fair Lawn–area residents believed that if they could secede from the rural township and become a borough as so many other towns had, it would be possible to get the votes for new schools. Many of the farmers were against this plan because they thought it would raise taxes. Proponents claimed that they were already paying taxes but not getting the schools their children needed.

The campaign for the establishment of a borough was a bitter one, with opposition meetings, delays and bus trips to Trenton to lobby for state approval. Finally, a referendum was held on April 5, 1924, and the voters approved the secession. Fair Lawn officially became a borough by an act

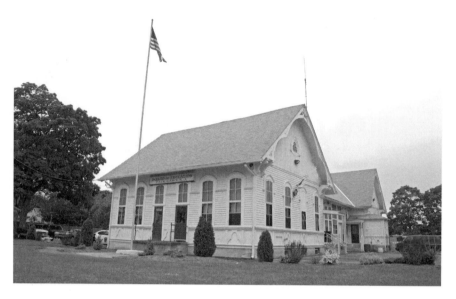

The Bergen Avenue School (Washington School) in 2008. *Photo by Ron Lotterman.*

of the legislature in May 1924. Unfortunately, the law called the new town "Fairlawn," and another law had to be enacted to correct the error.

The newly elected mayor and six-man council held their organizational meeting on June 2, 1924, in the firehouse of Company #1 on River Road with Mayor Robert Smith presiding. The council appointed the borough's first tax assessor, tax collector and building inspector at this meeting and adopted a building code. Later in the year, Nicholas Vanore was named chief of the force of marshals who policed the town, and a snow plow and tractor were purchased. However, there were no funds for a worker to plow the roads, so Councilmen William Croucher and Garret Houtsma volunteered their weekends to clear the streets when there was snow. The federal government, recognizing the new borough, established post offices in Warren Point on Broadway and at the railroad station on Fair Lawn Avenue.

A referendum in 1925 established a school district and a temporary Board of Education was formed. The board wasted no time in holding a referendum for the much-needed construction of a four-room school in the Columbia Heights section, which was approved by the voters and was called the Lincoln School. The first election for the school board took place in February 1926. The following year, the board instituted physical exams for entering students, bought "physical culture" equipment and held a successful referendum for purchase of a playground at the Warren Point School.

In the government's first full year of 1925, the mayor and council appointed the borough's first borough clerk, recorder, borough engineers, Board of Health and "poormaster"; adopted its first budget, amounting to $45,859; and awarded the first garbage collection contract of $3,500. In May, governing body meetings were moved to the Bergen Avenue School. By 1927, the need for municipal offices prompted the borough to purchase the Acker mansion and an acre of land for Borough Hall. On August 13, 1929, the new town officially made its home on the estate for which the borough was named.

In the meantime, the population of the borough continued to grow. In 1925, there were about 300 dwellings; by the start of 1929, the number had grown to about 1,500 houses, with an estimate of over 4,500 people. The governing body took steps to provide services to a town that was turning farms into housing tracts. The Fair Lawn Improvement Association, a Fair Lawn Center civic group, agitated for municipal water service. In 1927, the mayor and council created a water department and a referendum to build a water plant passed. (At the same time, a municipal incinerator was defeated.) Five wells were dug, and mains, a reservoir and a pump house

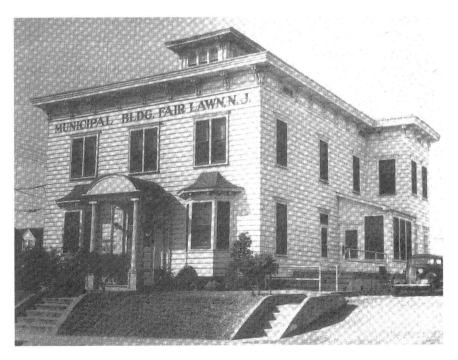

The first Borough Hall: the Acker House. *Courtesy of the League of Women Voters of Fair Lawn.*

were constructed. The sale of water began on January 1, 1931, at a cost of $4.50 per quarter for residential customers. The borough then purchased the Pomona Water Company, owned by Andrew De Boer, in Columbia Heights, and the Lyncrest Water Company, owned by P.L. Lynch.

A three-man Board of Tax Assessors was established to set values for all the new development in 1927—just in time, because in 1928 the borough approved the first subdivision map for a big project known as Radburn, a planned community that was destined to become world famous. Stores and a two-story bank building were built at the center of town, Fair Lawn Avenue and River Road. By 1930, Fair Lawn had grown to 5,990 people, a population meriting an upgrade to "village delivery" of mail. The same year, some citizens decided that the borough needed regular police patrols instead of part-time marshals. They circulated petitions through every section of town, including the new Radburn development, and collected hundreds of signatures. The governing body responded by establishing the police department.

The growth of the town made more schools necessary, and in 1929 there were successful referenda for four additional rooms at both Lincoln and Warren Point Schools and for an eight-room school in Radburn, on land donated by its builders. Later, voters approved the acquisition of land for a high school, but in 1935, in the depths of the Depression, they rejected construction of the school even though grant and loan funds were available from the federal Public Works Administration. In 1936, the people approved an addition, defeated in 1932, to Roosevelt School. A referendum to add four rooms and an auditorium/gym to Radburn School was approved by the voters in 1939.

The mayor and council continued to add services needed by a growing town. Prompted by the Fair Lawn Improvement Association, the council instituted a road department in 1931, and the eastern section of Morlot Avenue was paved with macadam from the railroad to Saddle River Road. A recreation commission and a shade tree commission were appointed in 1932. In the following year, cash had grown so scarce because of the Depression that teachers and borough employees had 50 percent of their salaries paid in scrip, which could later be redeemed for cash. A "relief director" to administer welfare was appointed in 1936.

The borough fathers saw the need for a planning and zoning committee in 1932. In the next year, the first zoning ordinance was adopted, and although growth had slowed because of the "hard times," a Zoning Board of Adjustment was appointed at the start of 1934. By 1939, growth had increased again, and a Planning Board was created to review the flood of subdivision applications for residential developments. Mayor Theodore Ferry,

in his congratulatory letter to the new appointees, noted that the borough council had just approved seven subdivision maps for 471 new homes.

In 1932, Maurice Pine, a young dentist who was concerned about the lack of a library in town, asked some fellow citizens to meet with him. They agreed to form the private Fair Lawn Library Association, to donate books and to seek funds and other members. Dr. Pine agreed to serve as president of the group. The State Library loaned the association 200 books, and the library opened in 1933 in an upstairs office of the bank building. In 1934, the borough raised its contribution to the library and provided it with a room in Borough Hall. The Works Progress Administration paid the salary of a full-time librarian in 1935 and also of an assistant starting the following year. By 1940, the book collection had grown to almost 4,500 volumes, and the library moved to three rooms in the municipal building.

Fair Lawn was a Republican town in its early years, but the administration changed every few years as opposing factions won control at the polls. In 1938, borough employees, frustrated by the patronage system that endangered their jobs every time a different faction took control of the government, gathered enough signatures to put the institution of the civil service system on the November ballot. In October, twenty-four employees formed an organization called the Anti-Slavery and Aborigines Protective Association of Fair Lawn and chose Samuel Greydanus, head of the road department, as its chairman. The organization was formed to "sever the shackles of the local political patronage system and plead with the voters for passage of the civil service rights question" at the general election and "become free men." Unfortunately, the referendum failed, and the employees had to wait until 1941 to gain the security of civil service.

# A VOLUNTEER COMMUNITY

Fair Lawn is known to its residents as a community of volunteers and organizations. By the time of its fifteenth anniversary in 1939, the borough had already shown the results of its volunteer spirit. The local farmers had erected the Grange Hall on Fair Lawn Avenue in 1905. Volunteer fire companies had been established (as related in the chapter "The First Fire and Police Departments"). The Fair Lawn Improvement Association, the Fair Lawn Community Club and the Radburn Citizens Association were early civic associations. The Improvement Association, made up of both farmers and residents of the housing in the Flats, was particularly active in

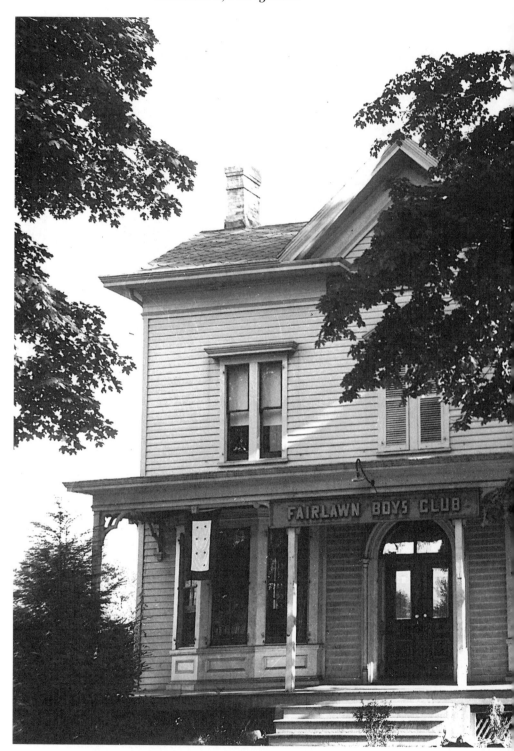

The Boys' Club.
*Courtesy of the
Cadmus House
Museum.*

pressing the government for every service needed by a community that was no longer strictly rural.

Volunteer parents established the first Boy Scout troop in 1926 and the first Girl Scout troop in 1927. By 1939, there were four Boy Scout troops, two Cub Scout packs, four Girl Scout troops and nine troops of Brownie Scouts. The Fair Lawn Athletic Club and the Raymond Street Playground Association were early private recreation organizations, and the Radburn Players dramatic group began presenting plays in 1931. The Harry Coppendyke American Legion Post was founded in 1930, taking its name from the Saddle River Road resident who lost his life in World War I. The Fair Lawn Boys' Club was organized in 1939 by Henry and Esther Milnes, Police Chief Michael Vanore and a group of local businessmen. The club served the boys of Fair Lawn for many years, providing facilities for basketball, table tennis, pool, boxing and other recreational activities, as well as classes in technical skills. On the third floor was the radio club run by Roger Carlton, an engineer at Bell Labs. Carl S. Carlson, a local real estate developer and boys' club trustee, secured eighty-nine acres of land in Kinnelon in 1944 for a summer camp featuring baseball, swimming, archery, riflery, woodsmanship and boating.

Most of the town's early religious organizations were started by groups of residents. In 1924, the only church building in Fair Lawn was the Van Riper-Ellis Sunday School chapel, where visiting ministers preached on

The original Van Riper–Ellis Church. *Postcard courtesy of Carol G. Bennett.*

Sundays. The Sunday school had been started in 1870 by Mrs. Eleanor Van Riper, with the aid of her neighbors, and was known as the Union Sunday School. The Van Riper-Ellis Memorial Church was formally organized in 1929. Three other churches—the Columbia Heights Community Church, the Church in Radburn and the First Baptist Church of Fair Lawn—were organized in Fair Lawn by 1930. In 1926, the congregation of St. Anne's Church moved from East Paterson (now Elmwood Park) to a new building on Summit Avenue. These five Fair Lawn religious organizations were not joined by others until 1940.

As the town grew, the residents of many of the new developments organized civic associations to represent their interests and to work for the good of the community. Republican clubs and, later, a Democratic club were established. In 1937, Kathryn Lyle founded the local chapter of the League of Women Voters, the first borough-wide women's organization.

In its first fifteen years, Fair Lawn had become a thriving, vibrant community, poised to manage its coming explosion of growth and become a modern suburban town.

# Industry and Commerce

Farming was the major industry in Saddle River Township, as in most of New Jersey in the eighteenth and nineteenth centuries. Early farmers grew not only grain but also all the vegetables the family needed. Every farm had pigs, chickens and dairy cows, and the settlers made their own soap and candles and wove their own cloth, burned lime for plaster, tanned leather and sometimes made their own shoes. Flax for making linen was grown in Fair Lawn across the Saddle River from Zabriskie's Mill at Garretson's Lane. As the farmers prospered, they bought slaves to help work the farms and do other chores. After the slaves were freed, most of them stayed on as farmhands or servants.

The early farmers were not entirely self-sufficient: they needed millers to grind their grain and blacksmiths to make their tools. We know that in the 1700s, Jacob Vanderbeck had a gristmill. There is evidence that there was a forge at Garretson farm. In 1745, Stephen Baldwin built a mill on the Paramus side of the Saddle River at the junction of the road to Hackensack and the Kings Highway, or Albany Post Road (Paramus Road). The mill property extended to the Fair Lawn side of the river and was the site of an early bridge. Jacob C. Zabriskie bought the mill in 1771 and operated it as both a sawmill for making logs into beams and smaller lumber and as a gristmill. Later, the mill was enlarged and converted for carding and spinning wool. During the Civil War, the mill, now owned by George Graham and painted red, wove blankets for the Union army. Hopper's Mill, on what later was known as Alyea's Pond, was another early mill. This pond lay west of today's Maple Avenue.

These early mills were powered by water. Rivers or streams were dammed to create a waterfall, which was channeled into a millrace. The current thus created turned the mill wheel, which was geared to a millstone for grinding grain into flour or to machinery for sawing, spinning, weaving or other purposes.

When a farmer did not need all his sons to work on the farm, some of the young men would take up other trades, especially carpentry. Other men set up shop as masons or wheelwrights, making wheels for farm wagons and carriages. In the early 1800s, the sons of the farmer George Doremus had found employment as tavern keeper, blacksmith, stagecoach driver and teacher. Garret Terhune bought a piece of the Garretson farm in 1813 and soon started a general store on Swamp Road across the river from the mill. Some farmers had ice ponds; ice would be harvested in the winter and stored for sale in the warmer months.

Taverns were important as social centers and gathering places for travelers, politicians, soldiers and ordinary citizens in the eighteenth and nineteenth centuries. Trials were often held in taverns since they were the only public places locally available. Justice of the Peace James Joralemon, who lived on Saddle River Road in the mid-1800s, tried cases at the Cockery tavern on Paramus Road. The Garrett Hopper House, formerly next to the Dutch House on Fair Lawn Avenue, may have been used as a tavern at one time, as evidenced by a ledger found in the house. The 1861 Hopkins-Corey map shows the Hamburgh Hotel next to tavern keeper George Doremus Jr.'s house on Saddle River Road.

By 1870, the area that is now Fair Lawn was home to six carpenters. Two of the Alyea brothers had a painting business and another was a miller. Several farmers were known as "market gardeners," growing fruits and vegetables for city dwellers in New York and Paterson. Henry Hopper was known as the Melon King for his vast acreage of the fruit grown for the New York market. There were also a blacksmith, a mason and a millwright, whose business was making the machinery for mills. The fathers of several families newly arrived from Europe and living in today's Fair Lawn, across the river from the Red Mill, were weavers or dyers, and two others in the vicinity were manufacturing picture frames. Stephen Terhune was a grocer at his store in this section, which by then was known as Red Mills. The store stocked a wide variety of goods; besides groceries and smoked hams, shoes and coffins were for sale. The store was considered important enough to be shown on Walker's 1876 atlas. The only other enterprise shown in our section was a "½ Mile Track" with a grandstand on Maple Avenue.

## GROWTH IN THE TWENTIETH CENTURY

The earliest known factory in Fair Lawn not connected with a water-powered mill was the Warren Foundry, built about 1895 on Second Street in the Flats, as the new housing development off Fair Lawn Avenue near the Passaic River was called. The foundry later did business as Warren Brass and Aluminum until the building was demolished in 2008. A tannery was established nearby on First Street at the river. This was later a slaughterhouse, which was succeeded by a fur factory. As the population of this section grew, there was enough trade for a tavern, which was located between Second and Third Streets on Fair Lawn Avenue.

Most of the town's early twentieth-century industry was located in its northwest corner along Maple Avenue off Wagaraw Road near the new homes in Columbia Heights. Here were the Wagaraw Bleachery and the Wagaraw Silk Dyeing Company. There were also thriving ice businesses at Alyea's Pond and Henderson's Pond. When a fire broke out at the former in 1915, the conflagration demolished ten buildings and the wagon sheds. Early stores were also established on Lincoln Avenue to serve the Columbia Heights neighborhood. In the early 1920s, the Textile Dyeing and Finishing Company was added to the industries on Maple Avenue, and later the Masson Dyeing Company and the United Piece Dye Works. The latter was still doing business in 1948. During World War II, some of these buildings were occupied by firms doing war work: the Wright Aeronautical Corporation made airplane engine parts in some of the buildings, and another firm made parachute cloth. Today, the buildings are owned by the Kem Manufacturing Company, making automotive products, and Fair Lawn Industries, which has a wide variety of tenants. There are preliminary plans to redevelop this old industrial area.

In 1906, the Interborough Rapid Transit trolley line, which connected Paterson with Hackensack, laid tracks from Broadway northward through Fair Lawn, roughly paralleling River Road. This meant that people living in the Warren Point section could get to shops in the Flats, which undoubtedly encouraged the growth of business there.

In 1911, Richard and Henry Kuiken established a millwork shop on Sixth Street near Fair Lawn Avenue. (The third brother, Nick, had a butcher shop and joined the business later.) A year later, the two formed Kuiken Brothers and started building homes; the windows were made in their shop. A lumberyard was added in 1921, and a paint store followed. At the time the borough fathers started talking about seceding from Saddle River

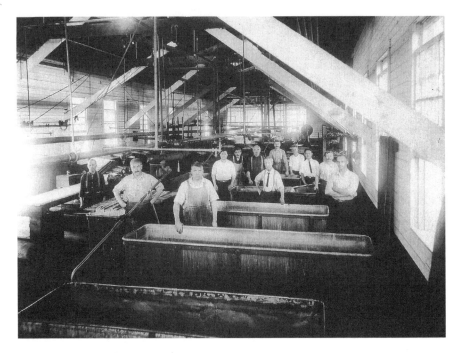

Workers at a textile dyeing factory, circa 1900. *Courtesy of the Cadmus House Museum.*

Township, many of their meetings were held in the Kuikens' store. When the Depression halted building, the Kuikens established their hardware business, which continues on Fair Lawn Avenue today. Kuiken Brothers is the oldest ongoing business in the borough and is now run by the third generation of the family.

Another enterprise started in the Flats was Landzettel & Sons Paints. Henry Landzettel moved his family to Fourth Street at Hopper Avenue and started a painting business in 1919. In 1932, he started manufacturing paint to sell to other painting contractors. The business expanded and moved north to River Road under the name of Lazon Paint products in 1949. After having been run by three generations of Landzettels, the manufacturing and retail enterprise was sold in 2008.

The Flats, later known as part of Fair Lawn Center, was also home to other early businesses, including the Fox Silk Mill, a bakery, Tillie Remery's store and Blote's well-drilling business. On the southwest corner of Fair Lawn Avenue and River Road was a tavern and hotel run by Ben Stein. In 1911, Fair Lawn's first volunteer fire company was organized at the hotel. Two weeks later, the building was destroyed by fire before the new company

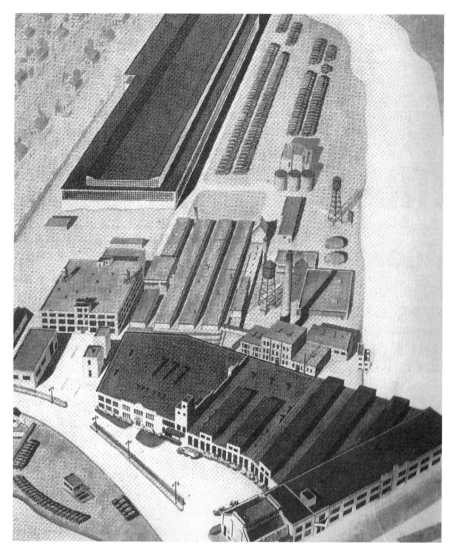

Fair Lawn Industries moved into the former Wright Aeronautical Plant #3 in 1947. *Courtesy of Evelyn McHugh.*

had had time to secure equipment. The hotel was rebuilt but burned down again in 1945.

In the early 1920s, several substantial brick commercial buildings, some having apartments on a second floor, were erected near the intersection of River Road and Fair Lawn Avenue. The Wyder Building, built in 1929 on the southeast corner, housed a bank on the first floor and offices on the

second. Here was the dental practice of Dr. Maurice Pine, who maintained a lending library in a next-door office. This later grew into the Fair Lawn free public library in its own building. The Fair Lawn Radburn Trust Company, formed by Fair Lawn residents, had its first banking facility in this building. Its successor, the Bank of America, still has a branch at this location. Other buildings housed neighborhood stores, such as a barbershop, candy store and pharmacy. A local institution still headquartered in the borough also had its start in Fair Lawn Center. In 1927, the Fair Lawn Building and Loan Association was established with an office in the Bergen Avenue School. The company moved to the Kuiken Brothers' building and then to Borough Hall. Finally, the firm built a home at Fair Lawn Avenue and River Road and became the First Savings and Loan Association of Fair Lawn. Today, the company is a regional institution, the Columbia Savings Bank, with headquarters in Fair Lawn.

Another long-lived local business, Joel Tanis & Sons Ready Mixed Concrete, was started in the family home on Twelfth Street between Berdan and Hopper Avenues. Mr. Tanis bought his first dump truck for delivering sand, gravel, topsoil and ashes in 1931. This author's husband recalls the pride with which the family members hosed down their first cement mixer in 1939. Demand grew so much during the borough's housing spurt in this period that in a year or two the firm bought its present site on River Road. The third generation of the family now runs the business, which delivers concrete throughout North Jersey.

Warren Point, in the borough's early days, was served by a post office, butcher shop, shoemaker, gasoline station and an A&P store. Industry developed along the railroad in this section. The Kimball Press was established early in the twentieth century and printed books, magazines and stationery, as well as the *Fair Lawn–Paramus Clarion*, the borough's first newspaper, and the high school's *Crimson Crier* weekly. The Turner Silk Mill was another early business. The Glen Rock Lumber Company moved its business to this area in 1941.

Soon after the Radburn Plaza Building was built in 1929 in the borough's fourth neighborhood, the structure had a complete array of shops to fill the everyday needs of the residents in the new town. Offices and community rooms were on the second and third floors of the building. George Sporn's gas station was located across the street. Radburn Brick and Supply was housed in two buildings on the edge of the new development, adjacent to the railroad. Here, bricks were made and lumber stored for the new homes being built. Later, the structures were the home of the Aridye Company,

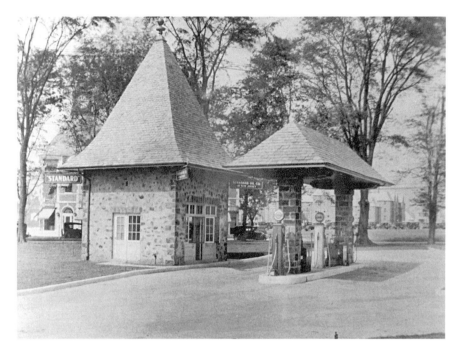

Sporn's Esso Station in Radburn, circa 1930. *Courtesy of Karl and Dan Sewall.*

which made textile printing inks. In the 1950s, Cole Engineering, a metal fabrication company, moved into the factories. Today, the buildings have been torn down, and the site is being remediated to residential standards.

## POSTWAR EXPANSION

The building boom after World War II brought an explosion of population to the borough, and additional neighborhood stores were built: on Saddle River Road at Morlot Avenue, on Morlot Avenue east of the railroad, on Fair Lawn Avenue at Chandler Drive to serve the new apartment development there and along Maple Avenue. At Radburn, new stores were constructed along Fair lawn Avenue and on Plaza Road—on the plaza for which the road was named. The River Road business district was extended southward to beyond Berdan Avenue and to the north at the site of the former Henderson's Pond. The River Road Improvement District was formed in 1995 with the aim of revitalizing the area. Special zoning permitting three-story buildings for stores with offices or apartments above has brought redevelopment to some

sites. New sidewalks and street furniture have been installed, and a loan and grant program for new signs and storefronts has resulted in face-lifts.

In the late 1940s, the League of Women Voters and other civic groups began urging the borough fathers to create a master plan for future development of the town. About the same time, the Fair Lawn Development Corporation, a McBride family company, was negotiating to buy the Croucher farm and other property on both sides of Route 208 from Fair Lawn Avenue to the Glen Rock line. The borough hired C. Earl Morrow, an early city planner, to draw up a modern zoning ordinance for Fair Lawn with provisions for an "industrial park" that would not intrude on the suburban character of the community. The ordinance, adopted in 1954, called for large lots and low buildings set back from the highway with green space in front. The park, dedicated in 1955 by then governor Robert Meyner, attracted manufacturing firms of national importance, including Nabisco, Kodak, Brioschi, Oxford University Press, Lea & Perrins, Sandvik Steel and Coats and Clark. Fair Lawn's industrial park became widely known as a model for industrial development. Today, changing economic conditions have led to remodeling of some of the factories into office buildings.

Broadway, which is also State Highway Route 4, is Fair Lawn's largest business district, with stores and shops running the highway's entire length in

Broadway at Plaza Road, circa 1950. *Courtesy of Evelyn McHugh.*

the borough except for an apartment development at one end and an office zone at the other. Business grew gradually from its starting point as a group of neighborhood stores near Plaza Road. A 1942 official borough street map identifies a "Theater" (the Hyway movies) and "Bowling Alleys" at two corners of Broadway and Midland Avenue as the only buildings of note in this area besides the Warren Point School and two churches. However, there were already many highway-oriented businesses by this time. When later in the 1940s the borough tried to rezone part of Broadway for residences to prevent excess business development and vacant stores, the court ruled that there was already too much business scattered along the length of the road to justify such a move. Broadway merchants have formed a Business Improvement District with the aim of revitalizing the commercial strip. A plan for the improvement of the district has been drawn and was presented to the governing bodies of Fair Lawn and Elmwood Park in 2009. The Fair Lawn Planning Board will study the plan for possible incorporation into the borough's master plan.

# Recollections

Members of the Seventy-fifth Anniversary Journal Committee interviewed Fair Lawn old-timers in 1998 and recorded their recollections. The author has recorded the reminiscences of some other early residents.

Ed and Evan Kuiken related memories of early Fair Lawn in a joint interview in April 1998. After telling how the Kuiken Brothers construction business was started by their father Nick and his brothers Rich and Henry in 1912, they talked of how "Uncle Nick Vander May bought the farm, my dad handled the property and Rich Kuiken built the houses." The property included George and Edward Streets and extended to the trolley tracks. The brothers recalled that "there was no electric in town; we used propane gas. All the roads were dirt roads when we were boys. Electric was put in Fair Lawn Avenue in the twenties." Remembering the paving of River Road in the early 1920s, Evan said, "They mixed the concrete on location. We used to slide down the chute." When Kuiken Brothers stopped building houses during the Depression and went into the lumber business, deliveries were made by "trucks with solid rubber tires."

Asked about politics, Ed told of infighting between the Young Republicans and the United Republicans. "An unusual thing? One day my Uncle Henry came in and said 'Kay Lyle got elected!' She was for women's rights—unheard of in them days."

———•·•———

Carol Greydanus Bennett spent an afternoon in the spring of 2009 telling of her memories of Fair Lawn in the 1930s. Carol was born in Fair Lawn, as was her father, Samuel Greydanus. His parents moved to Fair Lawn in 1899 and later bought a farm where the high school football field is now. Sam and his father grew vegetables for the Paterson market and sold unpasteurized milk from the small herd of cows. The family lived in a house on Romaine Street, now the site of the DPW.

Carol related stories that her father told her. "My father was very active [in Fair Lawn]. My mother and father were both on the bus that went to Trenton in 1924 [to lobby for separating from Saddle River Township]. Father was a fireman…He was a captain of the marshals until the police department started. He was also a justice of the peace. He had a favorite story about a young employee at Goldman's farm. Goldman told him he had no money to pay him and he would have to wait until Friday." The young man became so angry that he slit the tail of a cow. "My father gave him three months in jail."

Sam Greydanus was head of a two-man road department that had a grader and a dump truck. Carol told the story: "When it snowed, my father would plow with that huge grader—with no cab! He would come home at two o'clock in the morning just to get a cup of coffee."

Carol thought about her earliest memory of Fair Lawn: "We used to go down to what we called the briar patch where Memorial Park is now. That was all woods. We took our lunch in a paper bag. The sand pit had water in it. We would go to Brand's gas station and get old tubes and blow them up and float and swim in them. There were no adults."

Carol Bennett also wrote down some of her memories:

> *I lived on the corner of Berdan Avenue and Sixth Street…Today there is a pizza shop on that site. Directly across the street was a very large house owned by George Peterson and family. Mr. Peterson had a rose business with both national and international clients. They had their own private tennis count. This was very impressive to me…Today there is a Friendly's Restaurant on the site.*
>
> *Seeing the picture of Chief Vogel brought to mind the little stage productions the neighborhood kids would put on in his barn. His granddaughter, Betty, had a fine singing voice and sang on the radio. Of course, she sang in all our "productions."*

The Vogel family lived across River Road from the Greydanus house. Carol said:

*I remember they used to close off River Road from Fair Lawn Avenue to Hopper so we could go roller skating. That was the one smooth road we had. The reservoir next to the water tank was grassed over. We sledded down* [the sides]. *The wading pool near there…was a hub of activity. I remember the Fair Lawn bathing beach—a great place! We learned to swim there. It was all "make your own fun" in those days.*

After her grandmother died, Carol's family moved to her grandfather's farm on Romaine Street. "Father would milk the cows every day. After they sold them, we kept a 'family cow' and had milk and cream. Grandfather sold a couple of acres of the farm in 1938 or '39 to the borough for the DPW."

The Vanore family were early residents of the Warren Point section of Saddle River Township, before Fair Lawn became a borough. Interviewed for the town's seventy-fifth anniversary journal, Nick Vanore recollected

Postcard of the new Warren Point School, built in 1921. Names of the graduating class are on the reverse. *Courtesy of Nick Vanore.*

former times: "Fair Lawn was only a small town. When I graduated from Warren Point School in 1930 we had only nine boys. There were no girls." Nick recalled how Warren Point was isolated from the rest of town until Plaza Road was put through to Radburn.

> *On Broadway there was a shoemaker's...Ryan's gas station, the Post Office and the A&P...Mike [Nick's brother] had a phone in his house. He was a butcher...The Company #3 firehouse was opposite the Hyway theatre where the church is now...The Grunauer development had a few houses. Hartley Place had two-family houses. The [Turner Silk] mill was beyond that and the Kimball Press...They moved five houses when they widened Route Four.*

Caroline Fisher told me that she was born at 127 Heights Avenue, known as Bergen Avenue at that time, in 1908. She remembered that the first residents on that street in Columbia Heights were the Burgy family, who bought a house at 63 Bergen Avenue in 1899. Ms. Fisher recalled the famous 1903 flood that did so much damage. "The water came halfway up the block."

Jim Croucher's grandfather bought the Hopper farm in 1919. He and his three sons farmed the land until the sons sold it to the Fair Lawn Development Company in 1952 for the McBride industrial park. Jim Croucher grew up on the farm. In a 1998 interview, Jim talked about the 1930s:

> *There was no busing to school. You either walked through the woods when it was dry or on the avenue when it was wet...In the winter, people would bring their toboggans to Lowe's Farm, the high point on Fair Lawn Avenue. You could go all the way down to Berdan Avenue from there, which made it a beautiful ride—but a lousy walk back...In the decades after, there was an explosion of people and the farms gave way to houses and other development in what became the expansion of America.*

# The First Fire and Police Departments

## FIRE COMPANY NO. 1

Fair Lawn's first fire company was organized before the borough was incorporated. At a meeting in 1911 at the Fair Lawn Hotel on River Road, Charles Vogel, who had been a fire chief at his former residence in Hollis, New York, addressed his neighbors. He persuaded them that since there were so many new houses in the vicinity (then called the Flats), a firefighting organization was needed. The men formed the Fair Lawn Volunteer Firemen's Association No. 3, which became Fire Company No. 1 after the borough was formed. Vogel was elected chief of the new organization, and the hotel was designated as its meeting place.

Before the volunteers could secure equipment, the hotel burned to the ground. For some time after this disaster, the men met in a shed used as a temporary place of business by the innkeeper, Albert Schultess, who was a member of the company. Old-timers later recalled meeting surrounded by kegs of beer.

Original members of the company included many early Fair Lawn names: William Cadmus; Aaron Courter; Frank DeVuyst; Fred Fox; George and John Herman; Adam, Isaac and Garrett Hopper; Albert Kremers; Nick Kuiken; Dominick Lagrosa; Ben Stein, who later owned the Fair Lawn Hotel; Park Stephenson; Albert Thissen; and Harrison Vogel, among others. Many of these men had farms on Fair Lawn Avenue or River Road; others were owners of the new homes in the Flats.

About three months after it was formed, the fire company bought a hand-drawn hook and ladder truck from the Hohokus Fire Department for $650. Railroad car wheel rims, used as fire alarms by striking them with a metal rod or a hammer, were installed on River Road and on Fair Lawn, Hopper and Morlot Avenues. The truck was kept in Chief Vogel's barn on his farm at Berdan Avenue and River Road, and drills were held there; Mrs. Vogel served coffee to the men after the drills. Soon, the firetruck was fitted with "team poles." When the fire alarm sounded, the chief would unhitch his horses from the plow and hitch them to the firetruck.

In 1916, the fire company secured a property on River Road and started construction of a firehouse. The men made the concrete blocks, using molds that gave the blocks a surface like rough-cut stone. The building became the social center of the neighborhood, and the company sponsored a children's Christmas party and an annual picnic, aided by its ladies' auxiliary. The local justice of the peace convened court in the firehouse during the 1920s, and the organizational meeting of the first borough council was held there as well. Today, the company is housed in a modern building on George Street, one block from the original firehouse.

# THE WARREN POINT FIRE COMPANY

The Warren Point section of Saddle River Township originally included parts of Elmwood Park and today's Saddle Brook. A volunteer fire company for this section was first proposed at a meeting of the Warren Point Improvement Association, which met in its clubhouse on Fifty-fourth Street (Elmwood Park's name for Seventeenth Street). The Warren Point Fire Department was founded in 1912. Most of the members were from today's Fair Lawn, but the men met in the Fifty-fourth Street clubhouse. The volunteers bought a chemical hose cart that the men pulled to fires. The alarms consisted of railroad tires installed on Broadway at Fifty-fourth Street, the trolley crossing near the Passaic River and at Saddle River Road. The company disbanded when most of its members enlisted to serve in World War I.

When Fair Lawn was incorporated as a borough and new homes were built in the section, the need for fire protection was increased. The Warren Point Volunteer Fire Department was permanently established in 1924 at a meeting in the Warren Point School, with Frank Roughgarden as its first chief. The men set about raising money for a firehouse through

Fire engine, 1935. *Courtesy of Evelyn McHugh.*

bazaars, block dances and carnivals, and by 1925 their new pumper was housed in its own wooden building in Fair Lawn. The building was also used as a courtroom by the Warren Point–area justices of the peace. The company was incorporated in that year as the Warren Point Firemen's Association and in July was officially recognized by the borough council. In 1937, the volunteers built a new brick firehouse on Broadway near Hartley Place. Today, the company is housed in a building on Plaza Road at Rosalie Street.

## The Columbia Heights Hose Company

The early 1920s brought the addition of many homes to the Columbia Heights neighborhood, and the residents realized the need for an organization to fight fires. The Columbia Heights Volunteer Hose Company was founded on March 11, 1924, shortly before the borough was incorporated. A week later, the men elected Frank Davenport as the first chief. The volunteers installed two railroad tire alarms on Pomona and Albert Avenues and secured a hose cart that could be pulled by the

men or attached to a car. Bazaars and tag days raised the money for a used pumper from the neighboring Glen Rock fire company.

The company incorporated in June 1924 and wasted no time in securing two lots at Heights and Loretto Avenues for a firehouse, which was completed by the end of the year. The building became a center for social affairs in the neighborhood, notably the masked balls held by the volunteers.

Because there was no municipal water system in the early days of the fire company, water was drawn from the pumping system of local developer Andrew DeBoer. Residents were asked to turn off their garden hoses when the fire alarm sounded in order that there be sufficient water pressure for the fire hoses.

# THE RADBURN VOLUNTEER FIRE COMPANY

In December 1929, less than a year after they had moved into their new homes, nine Radburn men met and decided that the new town needed fire protection. They advertised a meeting in the *Fair Lawn-Radburn News*; among the signers of the ad was Thomas P. Knott, a future mayor of Fair Lawn. Several meetings were held, and in February 1930 twenty-three men formed a temporary organization, which became permanent on April 7 as the Radburn Volunteer Fire Company. John Marshall was elected chief and Leslie Price president. In June, the unit officially became part of the newly formed Fair Lawn Fire Department as Company No. 4, assigned to cover all fires east of the railroad.

At first the group was a "hand brigade." A hose reel and ladders were stored in a garage, and fire extinguishers were placed in various vacant residences. Soon, the Radburn Association, which administered the new development, donated a used pumper and firemen's gear to the company. The pumper was kept in a barn on Fair Lawn Avenue near Abbott Road. The men remodeled the barn to include a clubroom and a workroom, and as with the other firehouses, it became a center for social events, including a spring dance. In 1938, the company raised money and purchased land on Radburn Road at High Street for a new firehouse, which remains the home of the company today.

# Notable Fires

The most spectacular fire until modern times was the burning of all ten of Alyea's icehouses at River Road and Maple Avenue in 1915. Flying sparks from the blaze threatened the nearby bleachery and silk dyeing company buildings as well as neighboring farmhouses. The Fair Lawn volunteers, aided by adjacent volunteer companies and four companies from Paterson, managed to save all the nearby buildings, but electricity to Ridgewood was cut off and trolley service in Paterson was compromised.

The smoke and flames from the 1979 Glen Rock Lumber Company fire on Banta Place could be seen all over Fair Lawn. By the time the first firemen arrived, most of the lumber sheds were ablaze. It took all of Fair Lawn's volunteers and companies from four neighboring towns to control the fire and keep it from spreading to adjacent homes.

It was the coldest day in three years when all four companies responded to a 5:00 a.m. fire in one of the borough's oldest retail buildings on Fair Lawn Avenue. Because there were apartments over the store, one company was assigned to evacuate the residents while the others fought the fire. When the men found that several hydrants were frozen, companies from six neighboring towns were called in to assist. It was midnight by the time the chief declared the scene secure and told the volunteers they could get some sleep.

The Radburn Plaza Building had been the victim of two fires in 1937 and 1942, but the 2002 blaze that started in a basement gas line grew so large that the fire was covered by New York television stations. After the fire was extinguished, the south wing of the building was declared unsafe and had to be demolished. The wing was rebuilt to the original plans and reopened in 2005.

# The Police Department

Fair Lawn's first police force was organized at the borough's inception in 1924. The force consisted not of policemen but of thirteen marshals, who worked part time and were paid an hourly rate. The men used their own cars and were called by telephone as needed. Michael Vanore, who had been a constable for Saddle River Township, served as the first chief marshal. Later, the borough purchased a motorcycle for the marshals' use to patrol the main

Members of the first police department. *Courtesy of Evelyn McHugh.*

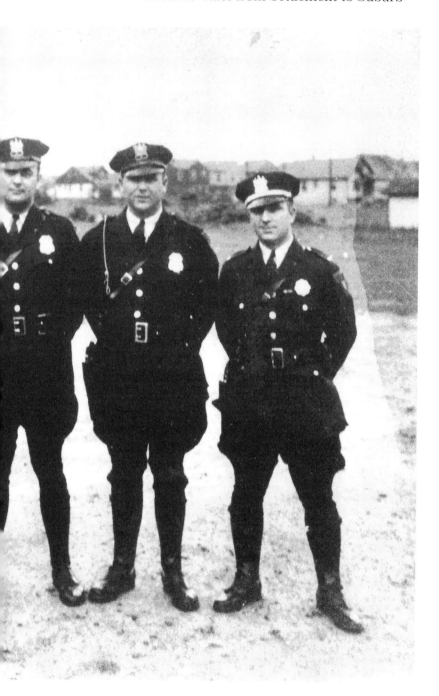

roads, which were busy with traffic on Sundays. Fair Lawn's rapid growth in the late 1920s made a full-time police force necessary. A police department of four officers, with Michael Vanore as chief, was created by the mayor and council in 1930 and increased to nine men by 1934. The new department had its headquarters in the municipal building in the former Acker House. Councilman William Croucher became the first police commissioner in charge of overseeing the new department. Since 1948, that job has been the responsibility of the borough manager.

Nicholas Vanore, who was appointed to the department in 1941, recalled his tour of duty in an interview in 1998:

> *When I got on the Police Department, the first job we had was walking patrol. We'd leave Borough Hall, walk to River Road and go all the way down to Morlot Avenue. There was a telephone box on Fire Company 1 and we'd call headquarters. Then down Morlot Avenue to Hartley Place and Route 4, where we'd call in from the box on Company 3. Then along Route 4 to Saddle River Road and up to Fair Lawn Avenue. And then back along Fair Lawn Avenue to the top of Radburn, where we'd call in from Company 4. That was your eight hours.*

During World War II, the department conducted investigations for the FBI as well as U.S. Army and Navy Intelligence. Residents employed by war plants were scrutinized, as were 189 aliens who were required to register with the police. Of these, 2 aliens were considered dangerous; they were arrested and later deported. Another duty of the early police force was manning the ambulance and answering emergency calls. In 1946, Chief Vanore asked for volunteers to help his over-burdened department, and six borough men aided the police until the Ambulance Corps was formed in 1948.

The police department was gradually enlarged as the borough grew. By 1949, at the town's twenty-fifth anniversary, the force stood at twenty-one men. This was increased to fifty-two by 1974 and stands today at sixty-three, plus eight dispatchers. Since 1960, the department has made its headquarters in the municipal building, which was completed in that year.

Police officers may be called on to risk their lives at any time. In 1998, a suspect being questioned in the field by Sergeant Michael Messina suddenly pulled out a gun. The sergeant yelled, "Gun!" to Patrolman Lou Evangelista, who had arrived at the scene. Messina grabbed the gun with one hand and the man's wrist with the other. Evangelista tackled the suspect, and Messina was able to secure the gun. Another time, things did

not turn out so well. Officer Mary Ann Collura was shot and killed while pursuing a suspect on April 17, 2003. A memorial to her bravery now stands in front of Borough Hall.

The Auxiliary Police Force was started in 1950 as the Police Reserves. Tensions created by the cold war and the Korean conflict caused the revival of the World War II Civil Defense Organization with a new name, Civil Defense–Disaster Control, or CD–DC; an important part of this effort was the Police Reserves. The volunteers were under the direction of a member of the regular force; Captain Louis J. Risacher (later police chief) was the first director of Auxiliary Police. By 1974, the reserve force comprised fifty-five men; today there are twenty members. Early duties of the auxiliaries included nighttime and weekend patrols, traffic control and aiding at parades and holiday celebrations. Today, they have the added duty of providing security at the municipal court sessions, and the volunteers are on call to assist in time of emergency.

# Radburn:
# The Town for the Motor Age

In May 1929, the first families moved into the new homes on Allen Place in the new town of Radburn, located in a mostly empty quarter of Fair Lawn. The City Housing Corporation had bought up most of the farms from Berdan Avenue to the Glen Rock border and from the Erie Railroad to the Saddle River, plus some other lands, for the site of its experiment in town planning, an American "garden city." An English-style garden city was not the eventual result, but the plan that emerged was to become world-famous for its system of "superblocks" with interior parks and its separation of pedestrian and automobile traffic. The planned community was advertised as "The Town for the Motor Age."

Radburn was designed by architect Clarence Stein and landscape architect Henry Wright, both of whom turned their talents to town planning. At the suggestion of Stein, New York developer Alexander Bing formed the City Housing Corp., a limited dividend corporation, in 1924 with the aim of creating "a Garden City in America." Stein and Wright started with the design of Sunnyside Gardens in Queens. The apartments and row houses were at the exterior of the city blocks and faced onto a common, block-long interior green space with park and recreation facilities. This idea, expanded, became the superblock with interior park of Radburn.

Promotional pamphlet for Radburn. *Author's collection.*

# THE RADBURN IDEA

Stein and Wright became concerned with the danger, congestion and pollution of motor traffic and determined to design, in Stein's words, "a town in which people could live peacefully with the automobile—or rather in spite of it." The planners wanted to separate pedestrian and auto traffic. Herbert Emmerich, City Housing general manager, produced a rough diagram of a superblock bounded by main streets giving access to cul-de-sacs surrounding the central parkland. This plan embodied the five elements of "the Radburn Idea": the superblocks; the separation of pedestrian and auto traffic; specialized streets for different purposes; houses "turned around" with kitchen on the street and living areas facing the walkways and parks; and the park as backbone of the neighborhood.

The Radburn plan acknowledged the growing prevalence of the automobile in American life and planned to accommodate it. By eliminating the traditional grid street system, the plan kept through traffic on main roads like Fair Lawn Avenue and used secondary, "collector" streets bordering the superblocks for access to the cul-de-sacs. Thus, most streets had only infrequent, local traffic. A pedestrian underpass connected the first two superblocks, and a wooden bridge, now gone, gave pedestrian access to the third superblock, the "South Side," across Fair Lawn Avenue. A walk through the park took people to the school or the neighborhood shopping center and offices in the Plaza Building. Both were provided with parking, however, for those who chose to drive.

Because the houses were turned around, the backyard was on the street, and living rooms and porches faced one another across a lane or walkway leading to the park. The walkways were placed where fences would have been in conventional development, and there were no fences in the side yards between homes. The lanes led to the parks, where children met to play and to walk to school.

The parks, in the center of each superblock and extending into the adjacent superblock, truly were the backbone of the neighborhood. Stein and Wright considered a neighborhood to be made up of several superblocks within a half-mile radius from a central elementary school. Each block was to be connected to its neighbor by an extension of the park. The original plan was for three neighborhoods with a high school and town center where the half-mile-radius circles intersected. Local shopping facilities were to be provided for each neighborhood.

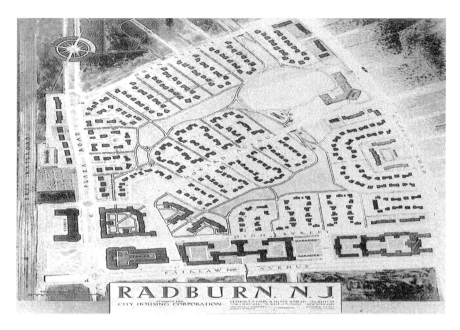

Plan of the first two superblocks, A Block and B Block. *Courtesy of the Radburn Association.*

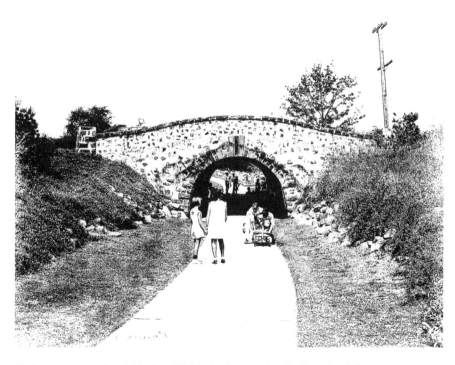

Underpass connecting A block and B block. *Courtesy of the Radburn Association.*

Radburn's unique street plan meant great savings in land development costs. There were fewer miles of streets and sidewalks to be paved and fewer miles of utility lines to be laid. The short cul-de-sacs designed for only slow traffic could be narrower than conventional grid-pattern streets and would require smaller water and sewer lines. The street area and the length of utility lines in Radburn were 25 percent smaller than those of a grid plan. These savings paid for the land set aside for parks and playgrounds and also for the grading and landscaping of these green areas. Unfortunately, the narrow cul-de-sacs were planned for one-car families and conventional automobiles and not for families with several cars and SUVs. Although most homes had a garage and a driveway for guest parking, this does not meet the needs of today's families.

Landscaping for the parks was designed by the landscape architect, Marjorie Sewall Cautley. Each park had a different theme and different trees and shrubs. The individual lots were also provided with trees and shrubs, often in the form of flowering fruit trees. Flower gardening became so popular that "lane contests" were held every summer to determine which lane had the prettiest gardens.

Many housing types were planned for the new town so that families of different income levels could live there, including workers in the factories planned for the southwest corner of the town at the railroad. In addition to single-family homes, there were to be single-family houses attached on one side, row houses (now called town houses), two-family row houses and apartment complexes. All but the apartments and a rental unit in each two-family house were planned for homeownership. All of these types were built, but unfortunately, even the most modest homes were beyond the reach of the poorly paid factory workers of the area, and the corporation succeeded in attracting only two industrial buildings. The idea of a town with employment for the residents had to be abandoned.

As it happened, Radburn was a homogeneous community in its early years. The residents were mostly young, middle-class families from New York and New Jersey. The workers, 70 percent of whom commuted to New York City, were employed as salesmen, professionals or junior executives. Some had their own businesses, including four doctors and a dentist. A survey done in 1933 by Robert Hudson, Radburn's first recreation director, found that 86 percent of the men and 75 percent of the women had attended college. Over three-quarters of the families belonged to a Protestant church, and about one-sixth were Roman Catholic. It is widely believed that Radburn was a "restricted" community in its early days, but Maxwell

Radburn in 1929. Row houses are sited between Plaza Road and the railroad in the foreground. *Courtesy of the Cadmus House Museum.*

Goldburgh, a real estate agent for the town, told this author that he made it a point to sell homes to two Jewish families early in the development. There was no formal policy of discrimination, but prospective residents were asked to answer a questionnaire that was used to determine if the family would fit in with the community's social environment. The town, which was meant by its planners to house a wide range of incomes, was encouraged by its administrators toward homogeneity in order to promote solidarity among the residents.

The similarity of the families combined with hard times to bring the community close together. Because the Depression began a few months after the first families moved in, money was scarce for almost all households. Nobody could afford a "night on the town," so Radburnites made good use of all the recreational activities provided by the Radburn Association and developed many themselves through the Citizens' Association, a body open to all residents. The Adult Education Committee of the Citizens' Association organized a program of courses, many of which were taught by Radburn residents holding doctorates in their fields. The woman who taught French, also a resident, had studied at the Sorbonne in Paris. There were

also practical courses, such as child study and woodworking. The Radburn Players' little theatre provided entertainment throughout the Depression when other amateur groups were "on hiatus." There were bridge clubs, the Garden Club, the Radburn Singers, the Friends of Music and the PTA. The Citizens' Association published the monthly *Radburn Reporter* in the mid-1930s. Adults organized teams for baseball, softball, cricket and bowling and clubs for table tennis and skeet shooting. And, of course, there were the parks and playgrounds, the swimming pools and the tennis courts.

# Community Government

The City Housing Corp. placed the government of the new town in a nonprofit corporation, the Radburn Association, governed by a nine-member board of trustees. The corporation's concern was not only to protect its investment but also to assure that the community would get off to a sound start with experienced management. The association was charged with providing and maintaining sewage disposal, garbage collection and street lighting; operating the parks and recreation facilities; plowing the snow from streets and sidewalks; and establishing the charges for these services, which were to be assessed on the basis of the value of each property. In effect, the association was to operate as a municipal government with a manager to administer the operation of the town. However, the trustees met in secret, and the only opportunity for formal public input was at the annual budget hearing. Clarence Stein, in his book *Toward New Towns for America*, called it "an American government without public representation!"

The board of trustees was a self-perpetuating body, made up of civic-minded persons and members of the City Housing Corp. Only one of the original trustees lived in the community. Gradually, the trustees replaced themselves with Radburn residents, but it was not until 1948 that all trustees were from Radburn. Over the years, the residents have made several, partially successful, attempts to have a more direct voice in their governance. In 1938, the residents organized a Special Evaluation Committee, which criticized the undemocratic nature of the Radburn Association and asked for open meetings and elected representation. A Radburn Association Committee on Election Procedures was formed by the trustees in 1969. In 1987, the Citizens' Association appointed an eleven-member Review Committee on Election Procedures, which recommended a plan acceptable to the trustees.

This process is used today. More recent efforts toward democracy have not been successful.

Today, six members of the board are elected by the residents from candidates selected by the trustees, two are elected by members of the Radburn Association and one seat is allocated to the president of the Citizens' Association, who is elected directly by the residents from candidates who choose to run for that office. As a result of an action brought by a group of residents, the trustees were ordered to hold open meetings when any vote is to take place and to publish minutes of their meetings, but the order did not include a mandate for fully democratic elections.

# A Landmark Community

The Radburn plan envisioned growth to twenty-five thousand people and the formation of a municipality separate from Fair Lawn. The Great Depression halted building in 1933, and the value of the un-built property fell to one-tenth of its original value by 1939. Many residents could not pay their mortgages. The corporation had to take back the houses and rent them, but the return was not sufficient to pay the expense of operating the community, especially the large sewer plant that was planned to service a whole town. The City Housing Corporation was forced to declare bankruptcy. Most of the un-built property was sold at a loss or acquired by the bondholders, principally the Equitable Life Assurance Company. City Housing reorganized in 1936 as Radburn Incorporated, and from 1939 to 1942 it built homes on its remaining land, finishing the three superblocks that had been started. The South Side was not finished on the original plan: the row houses planned for this section were not built but were instead replaced with one-family homes. The cul-de-sac system, with sidewalks leading to the park, was no longer feasible, since FHA financing required sidewalks on at least one side of the street. The remaining development around the South Side park was laid out on a curvilinear grid system.

The South Side may get an influx of housing. The board of trustees of the Radburn Association entered into a contract with Landmark LLC in 2004 to sell the underused Daly Field, provided the company secures borough approval for an apartment and town house development on the field and an adjacent parcel. Daly Field, in the southwest corner of Radburn, was acquired to substitute for Plaza Field after the latter was developed for

stores. The announcement of the contract, made without any public input, angered a large portion of the residents, who mounted a campaign to block the development. The borough council, which controls the zoning of the parcels, decided not to rezone the land from its one-family designation, and Landmark sued. At this writing, the future of the site is not decided.

Although Radburn did not fulfill its planners' dream of becoming a "New Town," it became a model for city and suburban development throughout the world. Its principles of separation of pedestrian and motor traffic, of superblocks with interior parks and of minimizing the street area were employed in planning of communities from the "greenbelt towns" built by the government in the 1930s to new towns and cities on several continents. Examples range from Baldwin Hills Village in Los Angeles to the new towns of Kitimat in Canada and Radburn's "sister city" of Ryokuen-Toshi in Japan. Brasilia, the new capital of Brazil, and Columbia, Maryland, among many other new cities, employ elements of the Radburn Idea.

Radburn was recognized as a State and National Historic District in 1975 and was elevated to the status of National Landmark by the Department of the Interior in 2005. The citation read, in part, "Radburn's design principles have influenced generations of community planning, including the three Greenbelt towns of the New Deal, many Federal Housing Administration–insured large-scale rental communities of the 1930s to 1950s, and new towns of the 1960s." Perhaps Lewis Mumford, urban critic and author, summed it up best when he declared in 1961 that Radburn was "the first major departure in city planning since Venice."

# Radburn: A Memoir

My family moved to Radburn in 1931. Number 10 Bolton Place was a brand-new house in a brand-new town with a brand-new school. My earliest memory of Radburn is walking through the park to the school with my parents and little brother and tracing the date on the cornerstone with my finger. Across the street from the school were deserted farm fields gone to tall grass, and half a block from our house were "the woods"—a friendly forest with a spring bubbling up from the sand and a shallow stream. The woods extended into Glen Rock, the next town, but most of the Fair Lawn side of the boundary was then part of Radburn.

We first explored the woods with our parents. When we were older, we children were allowed to go by ourselves and follow the little path along the stream. It had a stony sand bottom and was bordered by smelly skunk cabbage and other wet-soil plants. Now the stream runs in a pipe under the ground, but once we followed it all the way to the edge of the woods, in the adjoining town of Glen Rock.

Radburn at its beginning was a homogeneous place. Although it was designed with various housing types so as to be affordable to both blue- and white-collar workers, the development attracted mostly young families with fathers who were college-educated business and professional men and mothers who were housewives, mostly college women. Radburn School had nine classrooms, one class per grade, and all the children had northern European names. We knew all the kids in the school and most of their parents.

The stone bench in R Park. *Courtesy of the Radburn Association.*

The Radburn Association and the Citizens' Association offered a full range of recreational and educational opportunities for adults, which were well attended, partly because they provided free leisure activities in the depths of the Depression. All these community events meant that everybody knew everyone else in the new town. For a child growing up, it was a friendly and secure environment. We would meet our friends in the park, at the gazebo we called the "summer house" or at the "stone bench," meeting places for generations of kids and teenagers.

## SCHOOL AND PLAY

Before we went to school, some of us went to nursery school in the Children's House, a Victorian-style house built by Isaac Hopper, on Fair Lawn Avenue across from the Plaza Building. The building was also used for after-school activities such as Brownie Scouts and arts and crafts. In the summer, the preschool children went to "tot-lot" at the playgrounds in the morning.

The kindergarten in Radburn School was at the basement level but was at grade on the street side of the building. The room had cubby holes for our naptime rugs and an outside door leading to a semicircular play area enclosed by a low brick wall. Next to it was the teachers' room with a fireplace. There was no gym or assembly room, so this was used for PTA meetings. For a time, children took a break in the basement lunchroom to have milk in half-pint glass bottles; this was a Depression-era program to ensure that all children got at least some milk.

Recess took the place of physical education. We played "giant steps," "ring-a-leevio" and softball on the field next to Radburn's playground. When the weather was cold or rainy, we played "Simon says" in the classroom. Older kids walked down the road to the Grange Hall for indoor games. This was strange because the lower floor we used had a row of posts in the middle to support the upper assembly hall. We got more exercise walking to and from the Grange than we did inside it. In later years, the Radburn Association moved its headquarters to the building. The first floor was made into offices and a library, the upper floor became the clubroom and a gym and stage were added.

The greatest things about Radburn for the children were the parks and the recreation program. Walking to school through the park was perfectly safe—no parent needed to walk even the youngest child to school. The parks

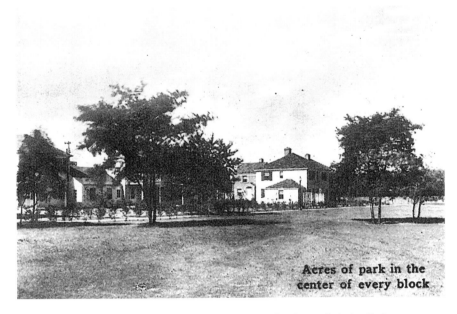

Early view of B Park from a promotional pamphlet for Radburn. *Author's collection.*

were also the place for improvised games or a round of batting practice with your father. In summer, there were playgroup and swimming lessons in the morning and more activities in the early afternoon: arts and crafts, tennis, archery and dramatics. Some years the playgroups (with adult assistance) staged a rather elaborate nighttime circus with sideshows in booths and performances in a ring. Kids and adults put on plays on the little stage in front of the summer house in "A" Park. *Robin Hood* was a memorable adult production. About 1940, a larger outdoor stage was built in the natural amphitheater in "B" Park. In 1941, the Radburn Players presented *Tom Sawyer*, starring Radburn eighth graders, and continued to produce a family play every June. For a time, the teenagers put out a semiweekly newspaper, the *Radburn Times*, with accounts of the latest camping trip or contest. Almost every weekend there was a special event: Wheel Day, with ribbons for the best-decorated bike, tricycle or doll carriage; pet contests; costume day; and overnight camping in the park.

In winter, there were after-school programs: Brownie and Girl Scouts, Cub and Boy Scouts, drama club, sports programs and "tumbling," now known as gymnastics. The girls took tap and ballet classes, first in a teachers' basement and later in the Club Room. For seventh and eighth graders, there was "social dancing," where we learned the Big Apple and the Lambeth Walk in addition to the waltz and fox trot. When it snowed, families trooped to the vacant field that extended from Radburn School to High Street, where there was a perfect hill for sledding. One side of the hill was a sand cliff where Radburn Road had been cut through. This was the spot for dare-devil jumps with a soft landing. Near the Grange Hall was Farmer's Hill for skiing—on quite rudimentary skis—when we were older. One day during World War II, soldiers appeared on our sledding field and established a base for units about to be shipped overseas. Radburn women gathered furniture and sewed curtains for the soldiers' dayroom, but we had to find another place for sledding.

We started swimming lessons when we were five. The two pools were not heated, so the water was cold until a few days before it was drained out every two weeks and scrubbed with chlorine by the lifeguards. But we learned to swim over one summer in spite of the cold water.

The swimming pools, one on each side of town, were the summer center of social life for parents and children. The pools were always busy. On hot days, the kids went swimming three times a day, including after supper with their fathers. The benches were made out of logs cut in half with a smooth sitting surface, and the pool was surrounded by a boardwalk,

B Pool in the early 1930s. *Courtesy of Ed Smyk, Passaic County Historian.*

Football on Plaza Field. *Courtesy of Felice and Laurence Koplik.*

which was an endless source of splinters. We felt very important when we could go to the lifeguard to have a splinter removed. The lifeguards—all young men—wore wool knit bathing suits consisting of a navy blue bottom and a white sleeveless top with "Radburn" in navy letters.

Plaza Field, across from the Plaza Building, was the site of the ball field where the men's softball league of eight teams vied for the championship in a series of after-dinner and weekend games every summer. The boys' baseball and football teams also played on this field until it was sold off for a block of stores after World War II.

# A SELF-SUFFICIENT VILLAGE

When my parents moved to Radburn, they did not have a car. Even in the "Town for the Motor Age," not every family had an automobile during the Depression. Most of the men commuted to New York City or other places by train or bus, which were within easy walking distance of all the homes. The bread man (Dugan's), the milk man and the vegetable man (Harry Brandes) regularly visited every home in their trucks. The stores in the Plaza Building had everything needed from day to day: grocery store, meat market, barbershop, shoemaker, hardware store and delicatessen. The stationery store and drugstore both had soda fountains, and after repeal, the drugstore had a liquor department. It also had little tables with wire ice cream parlor chairs and booths where boys could take their dates for an ice cream soda or a sundae. There was also the Dutch House Bar and Grill in an old stone house where our parents could go for a beer after a class or a play.

The upper floors of the Plaza Building accommodated the Radburn Association offices, a library, the clubroom and an assembly hall with a stage and a backstage for the Players. The hall was used for the Sunday services of the Church in Radburn, a nondenominational Protestant institution organized by Radburn's founders and five Protestant denominations. A large room next to the hall was used for the Sunday school. There were two doctors with home offices, a dentist's office and a piano teacher. Radburn even had its own private policeman, "Harry the Cop," friend to children, who walked a beat around the town. Later, he was presented with a bicycle on which to make his rounds. Charlie Daly, known to all residents, took care of the parks and public buildings. Daly Field was named in honor of his service.

A bus took you to neighboring Paterson (or New York) to buy clothes, shoes, toys and books or to go to a Catholic church, a Jewish synagogue or the movies. The bus also went to Fair Lawn Center, where you could visit the library, Borough Hall or the beauty parlor. For those with cars, Sporn's gas station was across Plaza Road from the present station in a quaint, specially designed building.

In the 1930s, Radburn, like the other three sections of Fair Lawn, was surrounded by woods and farms and isolated from the other villages. The people from other sections of the borough called the Radburnites "penny millionaires." Most of us were just as hard up during the Depression as they were, but we did have the pools and the parks, so they viewed us as thinking we were better than they were.

The isolation began to change when some Radburn residents became interested in local government and politics. Radburn men were elected to the borough council in the late 1930s, and resident Theodore K. "Ted" Ferry became mayor in 1939. Radburn residents also ran successfully for the school board. In 1937, Radburnite Kathryn "Kay" Lyle, reaching out to women from all parts of the town, founded the Fair Lawn League of Women Voters. What most made Radburn part of the mainstream of borough life was the opening of Fair Lawn's own high school in 1943. Before that, most Radburn students went to high school in Ridgewood, while most from other parts of town went to neighboring Hawthorne or Paterson. When Fair Lawn High School opened, those young people discovered that Radburn kids were really not different, and parents from the various sections got to know one another in the high school PTA. After World War II, housing developments were built at the borders of Radburn and it was isolated no more.

# Fair Lawn Becomes a Suburb

By April 1940, Fair Lawn had reached a population of 9,017 people, an increase of about 3,100, or 53 percent in a decade, despite the slowdown in building during the Depression. By this time, there were four established population centers: Warren Point, Fair Lawn Center, Columbia Heights and Radburn. These centers were still separated by farms. A survey made in 1943 found sixteen kinds of vegetables being grown and five varieties of fruit, including apples and peaches. There were also poultry farms and two dairies with cows, Goldman's Farmland-Fair Lawn Dairy and Lamring's Dairy.

A large part of the growth since 1930 had taken place in Radburn, where construction continued until 1933. Other parts of the borough saw development in the late 1930s. The opening of the George Washington Bridge in 1931 made the commute to New York City by car and bus easier, which attracted families wanting to move out of the city. The proximity to the jobs and department stores in Paterson was another factor. The Planning Board approved ten housing subdivisions in 1939, twenty-one the following year and fifteen in 1941. By May 1942, when the entire town registered for War Ration Book #1, the population was established at about thirteen thousand, an increase of four thousand people in only two years. Fair Lawn was said to be the fastest-growing community in the country.

This great surge in growth produced overcrowding in the schools, with many classes on split sessions. This situation was relieved by the opening of the new high school, housing grades seven through twelve, in September

1943. Before this, students had attended high school in Ridgewood, Paterson or Hawthorne. For the first time, students from all parts of the borough became acquainted, as did their parents through the high school PTA.

The drive for civil service status for borough employees was revived by the League of Women Voters, which petitioned for a referendum, held and passed in November 1941. In 1945, another successful referendum adopted the New Jersey Employees Retirement System for borough employees.

# FAIR LAWN GOES TO WAR

World War II brought great changes to Fair Lawn, as it did to every town and city in the country. Selective Service—the draft—was passed by Congress in September 1940 as the war in Europe threatened to spread. The first young men between twenty-one and thirty-five were drafted the following month to make up a peacetime preparedness force, which was planned to grow to over one million in a year. In May 1941, a state law required that a defense council be established in every municipality, and the Fair Lawn Defense Council was appointed the following month. When the attack on Pearl Harbor shocked even the isolationists into a patriotic fervor, the borough was ready to respond on the homefront.

The Defense Council, under the chairmanship of John Kriesmer, was expanded, and by 1943 there were committees for two dozen functions, including disaster defense, police reserves, first aid, safe shelter, victory gardens, salvage and air raid. Each block in town had an air raid warden. Air raid shelters in basements of public buildings were designated for those not in their homes should a raid occur. A "brown out" was put into effect by dimming streetlights with a coat of paint and mandating heavy drapes at every window. Victory gardens for growing vegetables to be canned later were set up in various parts of town. Schoolchildren were organized to collect newspapers and scrap paper. Boy Scout troops held salvage drives to collect metal to be used for arms and tanks; everything, from bedsprings to antique lamps, was collected. Every scrap of metal was saved, including the wires around glass milk bottle caps and the foil from cigarette packs.

Almost all of Fair Lawn's young men, including many seniors from the high school as well as many fathers, disappeared into the armed services as the draft was expanded to include men from eighteen to forty-five years old. Local women joined the men in Fair Lawn war plants on Wagaraw Road,

including Curtiss-Wright Aeronautical and a mill converted to making silk for parachutes. Two army bases were established: an antiaircraft base in Columbia Heights and a camp in Radburn for units about to be shipped overseas. The forty-two civic, social, service, religious, military and fraternal organizations in the borough formed the United Organizations of Fair Lawn to aid servicemen in the bases both here and overseas. A group of Radburn women furnished the local base with donated furniture and handmade curtains.

Rationing started with sugar and gasoline in 1942, to be followed by the issuance of ration books for tires, coffee, meat and dairy products, canned goods and shoes. Washington instituted "War Savings Time," an extension of daylight time, year-round to save electricity in offices. The government also mandated a wartime speed limit of thirty-five miles per hour to save gasoline and rubber tires.

Although little housing was built after 1942, when the government froze building materials except for war plants, Fair Lawn's population as reported at the issuance of the last ration book in 1944 had grown to over seventeen thousand. This was attributed to both an influx of workers attracted by the region's war industries and a huge increase in births following the departure of the men to the service.

When the war finally ended in August 1945, Fair Lawn had mourned the death of thirty-eight of its citizens.

# POSTWAR BUILDING BOOM

Building began again as soon as the war was over. In the years 1945 through 1948, the building department issued permits for 1,718 dwellings, businesses and industries, including 3 sizable apartment developments. Homes for over two thousand families were built in this period, including temporary veterans' housing on George Street and on the Warren Point playground. Block-long groups of stores were built on major roads in all sections of town. Housing developments displaced farms everywhere. Residential subdivisions that had been planned or started before the war were completed. By 1950, the population reached 23,865, having increased more than two and a half times in a decade. The building boom continued through the 1950s. Almost as many people were added as in the previous decade, as the population reached 36,421 at the 1960 census. The municipal government and the

Board of Education faced the challenges of providing facilities for the enormous influx of people.

Before the war, only Radburn and the adjacent Radrock had sanitary sewer systems. With the increase in population density, the need for a borough-wide system became apparent. In 1944, the voters approved a referendum authorizing bonds for the sewer construction, which was started as soon as peacetime materials became available.

The borough worried about funding the schools that would be needed to educate the baby boom children who were arriving in the thousands. When the Frank A. McBride Company proposed an industrial park on land along the new State Highway 208 in 1950, residents and borough officials resisted at first, fearing the loss of the town's residential character. But the need for ratables to lighten the tax burden of building schools, together with the park-like setting proposed by the developer, convinced the government and the people to accept the concept.

The McBride organization acquired the Croucher farm and adjacent properties extending from Fair Lawn Avenue to the Glen Rock line along Route 208 and the railroad—an ideal site for industry. The borough designed zoning for the development, ensuring light industrial plants on large lots with big setbacks and landscaped front yards. Nationally known firms were attracted to the site: National Biscuit Company, Eastman Kodak, Oxford University Press, Lea & Perrins, Coats and Clark and Sandvik Steel were among the early firms that built plants in the park. At the industrial park's dedication in 1955, Governor Robert Meyner called it "a model industrial community which gracefully fits into the plan for suburban living." The development was recognized nationally as a model for modern industrial development.

The Board of Education could not wait for the tax money from the new industry. The voters had approved a twelve-room addition to the Warren Point School in 1948, but the flood of children needing classrooms called for more than additions. Several schools were on double sessions to accommodate the students. The voters and the Board of Education produced a remarkable accomplishment: Fair Lawn built seven new schools and additions to three schools in the eight years from 1951 to 1958. These included the Milnes, Lyncrest, Edison, Westmoreland and Warren Point Annex elementary schools, two junior high schools and a twenty-nine-room addition to the high school. This feat was not without setbacks. In 1952, with the high school facing triple sessions, the voters defeated a bond issue for a junior high school and the Lyncrest

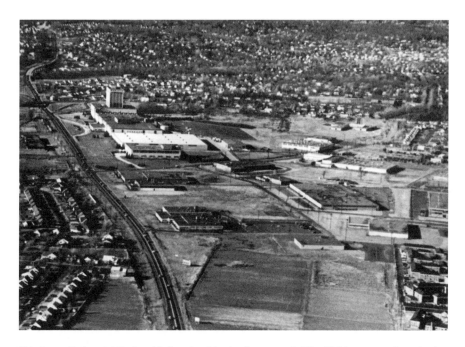

Fair Lawn Industrial Park, with farmland in the foreground. The Nabisco tower is at the far end of the development. *Courtesy of the Cadmus House Museum.*

Elementary School. Concerned parents formed the Citizens' School Committee and collected almost six thousand signatures on a petition for the resubmission of the junior high school bond issue. This passed narrowly. The Citizens' Committee, aided by the League of Women Voters and the College Club, continued its efforts to get school bond issues passed and school construction continued.

The growing town needed more than schools. When federal funding for the library stopped in 1942, the Library Board sought municipal status for the enterprise. With the support of the League of Women Voters, a referendum for a free public library with mandated borough funding passed in 1944. The library again outgrew its quarters and moved to a store building on River Road in 1945. As the collection and circulation continued to grow along with the increasing population, the library moved again in 1950 and expanded in 1952, but it was still housed in store buildings on River Road. Service was expanded when the Bookmobile, a traveling branch in a bus, started visits to every neighborhood in 1956. This popular service continued for over twenty-five years, with Hazel McCurdy, known everywhere as "the book lady," as its librarian.

Fair Lawn's first professional librarian started work as director in 1958. Henry Thomas instituted new programs and extended library hours, but he also campaigned for a new building, one designed specifically for library needs. A state-of-the-art library, later named for its founder, Maurice M. Pine, was opened in 1967.

In 1945, the first full-time recreation director started work, and a youth canteen for teenagers was established in a vacated army barracks at the Columbia Heights field (now the Dobrow Sports Complex). The council appointed a Recreation Committee, which in 1948 recommended that the borough acquire an additional fifty-seven acres of land to add to the eighty-seven acres already dedicated for recreation. Many neighborhood parks were created when the Planning Board persuaded developers of large residential projects to set aside green areas. When Monte Weed, a recreation professional, started work as superintendent of recreation in 1949, Fair Lawn started on a program of expansion and innovation in leisure activities. A new youth center was opened in 1957. A master plan for park development, with input from a citizens' advisory committee, was instituted in 1968. By 1974, supervised summer programs were held at fourteen borough and school playgrounds, up from four in 1945. Many new activities were added, including summer day camps, gymnastics, soccer, wrestling, lacrosse and yoga. The adult cultural center housing the Old Library Theater, the Ham Radio Club and other programs was opened in the former library building in 1968.

The municipal staff needed to serve all the new people in town outgrew its old quarters. A new Borough Hall for local government offices and the police department was completed in 1961 on the former property of the Raymond Street Playground Association.

As another result of the influx of people, thirteen new religious congregations were formed in the borough between 1940 and 1966, including eight Protestant and five Jewish congregations. St. Leon's Armenian Apostolic parish moved from Paterson to Fair Lawn in 1965.

After many years of study and advocacy, the League of Women Voters persuaded the governing body to take steps toward the adoption of a master plan for development of the town. The mayor appointed a Planning Advisory Committee in 1953. To save tax money, the members undertook to make basic studies of existing conditions, including a detailed inventory of land use. A planning consultant was hired two years later. In June 1956, thirty-three league members and ten other volunteers stood at sixteen major intersections and counted cars under the supervision of the planning firm.

The "Ultimate Development Plan" presented by the Planning Board in 1958 was not well received by some citizens, largely because of some proposed street widenings and the fear that the planned public improvements would result in huge tax increases. The basic studies were updated, and a new draft plan was studied by the Planning Board starting in 1962. Finally, in 1966, Fair Lawn's first master plan was adopted.

## STILL A VOLUNTEER COMMUNITY

The volunteer spirit of Fair Lawn's citizens turned after the war to continued improvements to the town. Helda Walsh, a Boys' Club director and member of the Columbia Heights Association, persuaded the mayor and council to allocate the land around Snyder's Pond for a swimming pool. The area residents held fundraising events and provided the manual labor to turn the area into a bathing beach. The Columbia Terrace Pool Association ran the pool for many years until it was taken over by the borough in the 1970s. In 1962, it was renamed the Helda Walsh Pool in memory of its late founder.

Postmaster Cameron "Mac" McCurdy and his neighbor Bill Eaton became concerned about the drownings at the deserted sand pit near the Passaic River, which had filled with water and attracted young people in the summer. The men thought the thirty-three-acre borough-owned property could be developed into a park and pool, but municipal funds were not available because of the high costs of the sewer project. The men asked the Fair Lawn Men's Club for help. Members of the wartime United Organizations suggested that the park be dedicated as a memorial to borough servicemen killed in the World Wars and donated the club's remaining funds for the project. In 1948, the Memorial Park Civic Group, Inc. was formed and worked to obtain voluntary labor and materials and to raise funds. Thirty-two local builders, contractors and other businesses donated equipment, materials and services to grade the pool bottom, beach and parkland and to construct roads, a bathhouse and other facilities. The park was dedicated on May 29, 1949, as part of Fair Lawn's twenty-fifth anniversary celebration.

In 1948, the 6 volunteers who were aiding the police in emergency transportation to hospitals became members of the new Volunteer Ambulance Corps, which soon attracted 20 new members. The Warren Point Square Club purchased the first ambulance for the corps, and its

The sand pit before it became Memorial Pool. *Author's collection.*

members took courses in first aid and obstetrics. The Civil Defense–Disaster Control organization was formed in 1950 at the time of the Korean conflict. By 1957, CD–DC had 1,025 volunteers, most on a standby basis, in its numerous divisions.

The All Sports Association was organized in 1950 to promote junior football and other youth sports in cooperation with the Borough Recreation Department. By 1974, the program had grown to include twenty Little League teams (later known as Major League baseball) as well as teams for baseball for other age groups, softball, basketball, football, lacrosse, wrestling and cheerleading. Hundreds of parents and others served as coaches and referees.

Volunteer groups started an adult school (now the Community School, run by the Board of Education) in 1950; a mental health center in 1959; and the Opportunity Center for developmentally delayed adults in 1965. Other volunteer organizations over the years have included those promoting the library, schools, parks, senior citizen housing, preservation of historic buildings, hospitals, the arts and indoor swimming; and those fighting drug abuse, crime and drunk driving. These were in addition to local chapters of national service organizations.

In 1953, the National Municipal League and *Look* magazine named Fair Lawn one of eleven "All-American Cities" for the "constructive and intelligent action" of the Citizens' School Committee (for supporting new schools) and the Nonpartisan League (for supporting council-manager government). Citizen action in converting a sand pit to a swimming pool and park was also recognized.

Perhaps the bravest of the volunteers are those serving as volunteer firefighters. Their history can be found in the chapter "The First Fire and Police Departments."

Fair Lawnites were great organizers. In addition to the volunteer groups formed as the borough grew, civic associations for residents of new housing developments, fraternal organizations, veterans' posts and borough-wide civic improvement groups were established.

By 1970, Fair Lawn had reached a population of 37,975, according to the census for that year. This was probably an over-count, since the following census tallied over 300 *fewer* housing units than previously in one district. The actual population was probably about 37,000, making the borough one of the largest municipalities in Bergen County. Fair Lawn had indeed become a thriving modern suburb.

# Changing the
# Government—Over and Over

Fair Lawn adopted the mayor-council form of government when the borough was established in 1924. Six councilmen and a mayor were elected, all Republicans. Each councilman was in charge of one or more functions of the government, such as water supply; police and fire; roads; and finance.

In 1938, there was talk of changing the government to the municipal manager form, in which an appointed manager runs the various departments under policies set by a five-member borough council elected on a nonpartisan basis, with elections in May rather than November, and no national parties listed on the ballot. The League of Women Voters, founded in 1937, studied this "modern" way of running a town, which was authorized by the state in the Municipal Charter Law, or Walsh Act, of 1923. The league endorsed a change to this new form.

In 1940, the citizens elected a new administration—still all Republicans—under the leadership of Mayor Theodore Ferry. The slate had pledged to investigate council-manager government. After a four-month study, a committee recommended the new form, but a petition of the people to have a referendum for the change failed to secure enough signatures. At the time, many people did not want to pay a manager to do what the councilmen did without a salary.

Municipal manager government came up again in 1946, when the people elected the first three Democrats in the borough's history, including Mayor Charles Yerger. The handling of construction of the new sewer system, which

had been approved by a referendum in 1944, had been the primary reason for voter dissatisfaction with the incumbents. The Democrats had pledged to work for a referendum on the new form of government. The League of Women Voters organized a fact-finding committee of eleven civic clubs, which endorsed the idea. The group formed the Citizens' Committee for Council-Manager Government and was successful in securing the required signatures to petition for a referendum. Two more Democrats pledging to work for the new form were elected in 1947, including Fair Lawn's first councilwoman, Kay Lyle. The Republicans did not support the referendum, but it was passed on February 24, 1948, and the election for five council members for the new form was held in March. Ironically, four of the five Republicans running under the Businessmen's banner were elected, although Yerger received the highest vote. Under the new system, the council members elected John Pollitt as mayor.

A group of citizens, many of whom had been active in the Citizens' Committee, formed the Non-Partisan League to sponsor a slate of candidates made up of Democrats and Republicans. The group was successful in maintaining a majority on the council from 1953 until 1958. A scandal involving alleged bribes over a garbage contract returned to power the mainstream Republicans, running under a "Clean Government" banner, in the election of May 1958. Richard J. Vander Platt earned the distinction of being Fair Lawn's longest-serving mayor, having been chosen by his colleagues for that position from 1958 through 1968.

By 1973, Fair Lawn had changed to a majority Democratic constituency, as evidenced by the November elections for non-borough offices. A group of Democrats petitioned for a referendum to change the government to a council-manager form of government under Plan E of the Optional Municipal Charter or Faulkner Act, with biennial, partisan elections in November. The thinking was that in November, more people would turn out and tend to vote a straight party ticket, and Democrats could be elected to the council. The Republicans had tried this tactic earlier when they were in the majority, but the referendum had been defeated. This time, the referendum passed, mandating an election for all council seats in November 1974. The Democrats won and held the majority from 1975 until July 1981.

In 1979, a group of local Republicans and the League of Women Voters each circulated petitions calling for a return to nonpartisan elections in May. The borough clerk determined that there were insufficient valid signatures, but the Republicans appealed the decision in court, in part because the clerk had made his decision after the twenty-day period required by law.

**FAIR LAWN VOTERS...**
**REPUBLICANS**
**WANT TO CHANGE**
**COUNCIL ELECTIONS TO MAY**
**FOR THEIR OWN BENEFIT**
**— NOT YOURS!**

**1. May Elections are as partisan as November elections.**
—candidates are chosen and supported by political clubs in both.

**2. May Elections deprive you of your right to choose candidates in the June Primary.**
—back room politicians choose candidates for you.

**3. May Elections are not recognized by a majority of voters in Fair Lawn.**
—only 25% to 30% of those registered voted in May compared with 65% to 90% who vote in November.

**4. May Elections will cost Fair Lawn a minimum of $15,000 extra each year and will increase with inflation.**
—taking money from needed Borough services, or raising taxes.

If Republicans want representation on the council, let them speak out on the issues in Fair Lawn and make their positions known!

Trying to fool the residents with false promises of "non-partisan" government is a dishonest attempt to gain council seats.

**VOTE NO ON MAY 27**

Pd. for by David Goldberg, 12-82 River Rd., Fair Lawn

*Left*: Advertisement opposing nonpartisan elections. *From the* Fair Lawn–Elmwood Park–Saddle Brook Shopper.

*Below*: Opinion piece favoring nonpartisan elections. *From the* News Beacon.

Page 4     The News Beacon 5/23/80

 **League of Women Voters**

# The League favors May elections

**by Gloria Korn, Fair Lawn chapter**

The referendum on May 27 gives the people of Fair Lawn an opportunity to return to annual May elections for the borough council instead of elections every other year in November. The referendum has nothing to do with taxes. It will not change the present Council-Manager form of government in Fair Lawn.

There are many good reasons for a community like ours to hold annual elections in May. Local issues are different from state and national issues. During November elections when state and national issues are in the forefront, newspaper coverage concentrates on them rather than on local issues. Candidates who are not particularly active in the political parties but who would be willing to serve in local government have a better opportunity to reach out to the voters in May. There are many people in our town whose primary interest is participation in local government and prefer a non-partisan campaign.

A vote in favor of the referendum will result in another change. Council members who are elected will serve for a term of three years instead of four years as they do now. Shorter terms tend to encourage more responsive council members. Annual elections keep municipal issues before the public without the distraction of partisan politics.

For more than 40 years the League of Women Voters of Fair Lawn has been in favor of May elections for municipal officials. We advocated the hiring of a professional manager who is not a resident of Bergen County. It is the opinion of the League that a non-resident professional is less likely to be involved in local politics.

Ever since the League took its first stand for Municipal Manager Government in 1938, we have been concerned with WHEN elections are held, not with party affiliations. As a result, the League has been opposed at different times by both the Republicans and Democrats.

May elections provide that no party labels be placed on the ballot. Candidates run on the basis of stands on local issues alone. The League of Women Voters believes that this is the ideal way to successfully conduct council elections.

The Faulkner Act stated that Council Manager government worked better with separate local, non-partisan elections. And, to quote Charles Kneier, Professor of Political Science at the University of Illinois in his book *City Government in the U.S.*, "The question of national and state politics have nothing to do with the honest, expeditious and prudent administration of municipal affairs."

The League supports a yes vote on May 27.

The superior court judge declared that the petitions had sufficient valid signatures, but the borough attorney appealed. The appellate court judge upheld the decision of the lower court. The referendum was held on May 27, 1980, and was passed after hard-fought campaigns by both supporters and opponents. The Fair Lawn Independent Democrats organization broke with the older United Democratic Club to support the referendum. In the election of May 1981, the Coalition of Independent Voters and the Alliance for Borough Council each presented slates made up of members of both parties as well as independents. The Good Government Team ran a slate of Democrats. The Alliance candidates won the election and chose as mayor Florence Dobrow, the borough's first woman to hold the position.

After this, the majority on the council shifted between parties until 1987. Although candidates were not permitted to run under a party label, the party of each person running was public knowledge. The last phase of this game of changing the date of local elections started in 1986, when still another referendum returned the government to partisan elections, starting in November 1987. Democrats have retained the majority since January 1988, although Republicans and independents have been elected from time to time.

# Fair Lawn Up to Date

Fair Lawn Board of Education faced a dilemma in 1979: the student population had fallen 40 percent since its peak, to a point where maintaining the school plant of ten schools was considered a luxury that the taxpayers did not want to support. The school budget had been voted down. The Washington School on Bergen Avenue had been closed in 1959 and converted to offices for the Board of Education. Lincoln School, which had been used for special education classes, was closed and the classes moved to the Warren Point Annex. Now the problem was which building or buildings to close next. Parents fiercely defended the principle of neighborhood schools and lobbied to save all seven elementary schools.

The school board proposed several plans for housing the grades, including changing to a middle school or closing both junior high schools. After much study and debate, the board voted to close the Thomas Jefferson Junior High School, send the ninth-grade students to the high school and transfer all seventh and eighth graders to Memorial School. The Thomas Jefferson School was used for a period as a community center, administered by the school board and housing the board offices, the Community School for adult education, the borough recreation department, the Alternative High School and many recreational activities. In 1983, the elementary Edison School was closed as well, and today it is used for various educational functions, including the offices of the Board of Education and the Community School.

Fair Lawn's population had decreased from about 37,000 in 1970 to 32,229 by April 1980. The baby boomers had grown up and most had moved away.

But their parents stayed in their homes or were replaced by other empty nesters; household size decreased markedly. The last large tracts of land had been developed by 1970. The slowing of building meant that there was no longer an influx of new families with children. The 1980 census revealed that 71 percent of households had 3 or fewer people, and the percentage of senior citizens had risen from 9 percent in 1970 to 14.3 percent in 1980.

In 1970, the Fair Lawn Junior Chamber of Commerce joined the League of Women Voters in a town-wide survey that determined a need for special housing for low- and moderate-income seniors, either in a new project or in existing housing through rent subsidies. Rent subsidies were obtained, but this did not fill the need for new housing appropriate for the elderly in a time of high rents. The Senior Citizen Housing Corporation was formed to seek federal senior housing funds, but the funds were frozen before a site was found. The corporation continued to seek a housing site and to secure state funding, but the effort eventually failed.

A more successful effort was the construction of the new Senior Center, a project championed by Councilwoman Florence Dobrow. The center was opened in 1980 and provides recreation, social gatherings and a lunch program. The sixty-five-and-over population continued to grow—to 20 percent at the 1990 census—prompting an addition to the building. The free Fair Lawn Mini-Bus service was established to help seniors get around town, but it is now available to all residents.

Most of the large tracts of land had been developed by 1970, but smaller tracts were filled in with small apartment projects or one-family homes. In 1983, the Planning Board approved the first town house development. The board studied what pieces of vacant land might be suitable for this new type of housing and developed standards for it. Several town house areas were placed on the master plan and in the zoning ordinance, and all were developed. Still, the population continued to decrease through the 1980s, although it grew in the following decade. A new apartment project for market and affordable units was built on land previously reserved for industry and supplied a portion of the borough's obligation to build housing affordable to low- and moderate-income households. The Planning Board adopted a new master plan in 1992, and in 2009 it was considering a plan for the gradual evolution of the industrial park into a mixed-use development with areas for offices, industry and housing.

Schools were in the news again in 1988 as new state regulations setting standards for minimum classroom sizes for even small classes caused overcrowding in four of the six elementary buildings. Schools

that had been at half of their designed capacity in 1983, according to the state formula in that year, were considered overcrowded under the new regulations. Trailers, or "relocatable classrooms," were being used at two schools. The problem was solved by reopening the Thomas Jefferson building as a middle school and moving sixth-grade students to the two middle schools. Since then, additions have been made to several schools, the largest one to the high school, which was experiencing an increase in enrollment.

The recreation program continued to expand. Today, there are fifteen dedicated parks and playgrounds. The recreation department offers thirty-nine indoor and outdoor activities, from baseball to bridge. The department also sponsors special events, including holiday celebrations, contests and outdoor concerts, some in cooperation with other organizations. In addition, the All Sports Association sponsors nine sports, some with many teams. The program serves thousands of Fair Lawn children and hundreds of parents and others serve as coaches and referees. A new community center, replacing the youth and adult centers, was opened in 2006. The center was later named the George Frey Center for Arts and Recreation in honor of the late recreation director who oversaw the staffing and operation of the new building.

## STILL A VOLUNTEER COMMUNITY

The spirit of volunteerism in Fair Lawn is still strong. The pressure to develop every piece of vacant land alerted the citizens and civic groups to the need to preserve precious resources and maintain a healthy environment. In response to the citizens' concerns, the governing body created an Environmental Commission, a Historic Preservation Commission and an Open Space Committee to monitor development, inventory resources and promote their preservation.

The men and women who serve on the other official boards and commissions that help to run the borough are also dedicated volunteers. The Planning Board, the Zoning Board of Adjustment and the Economic Development Corporation continue to help to plan the growth of the borough. The Library Board hires the library director and oversees the operation of the library. The Health Advisory Board, the Alliance for Substance Abuse Prevention and the Americans with Disabilities Committee look to the

The Maurice M. Pine Public Library. *Courtesy of the League of Women Voters of Fair Lawn.*

health and safety of citizens. The Garden Committee and the Shade Tree Advisory Community work to beautify the borough. The Fair Lawn Historic Sites Preservation Corporation runs the borough museum at the Cadmus House. Local volunteers also staff the Garretson Forge and Farm Museum, although it is a county institution. The Broadway Special Improvement District and the River Road Improvement Corporation work to upgrade these business districts. The Rent Leveling Board administers state and local rent regulations. The Health and Human Services Department coordinates applications for volunteers for Meals on Wheels, the food pantry, the Senior Center, the dog and cat census and litter cleanup days.

The Civil Defense–Disaster Control organization became the Office of Emergency Management in 1992. It is run by a coordinator and a deputy coordinator who are borough employees, but its seven divisions are staffed by about 150 volunteers, including the Auxiliary Police, the Rescue Service and the Nursing Division.

Today, the members of the much-enlarged Volunteer Ambulance Corps are all trained as emergency medical technicians. The corps raises money for both its ambulances and its headquarters building, newly enlarged in 2009 to provide sleeping quarters for the duty crews.

The volunteers of over twenty-five civic, cultural, educational, recreational and social service organizations work to enrich the lives of Fair Lawn's residents. These groups include those fighting drug abuse and crime and those supporting the library, education, health, recreation, the arts, local television and citizen participation in government.

The U.S. Census for the year 2000 showed that the borough had grown to a population of 31,637. The estimate for 2009 was 32,000. The town has grown more diverse as people from every continent have found homes in the community. There are now over twenty houses of worship serving people of many languages and faiths.

Fair Lawn can take pride in its many institutions and facilities. The high school won recognition in 1992 and again in 1998 when it merited the Presidential Blue Ribbon Award for Excellence in Education. The Maurice M. Pine Library, with a collection of almost 200,000 books and many programs for all ages, is regarded as one of the best in the state. Fair Lawn is home to two museums in historic houses. The parks offer green areas in every neighborhood, and the recreation facilities provide opportunities for sports, hobbies and cultural events for young and old. Fair Lawn is truly an up-to-date community.

# Bibliography

## THE LENAPE: THE FIRST INHABITANTS

Jennings, Jesse D., ed. *Ancient North Americans*. New York: W.H. Freeman & Co., 1983.

Johnson, Selina Tetzlaff. *Bergen County, New Jersey History and Heritage*. Vol. 1, *the Land and Its First People*. Hackensack, NJ: Bergen County Board of Chosen Freeholders, 1983.

Kraft, Herbert C. *The Lenape or Delaware Indians*. South Orange, NJ: Seton Hall University Museum, 1991.

Livingston, Rosa A. *Turkey Feathers, Tales of Old Bergen County*. Little Falls, NJ: Phillip-Campbell Press, Inc., 1963.

Lutins, Allen H., and Anthony P. DeCondo. "The Fair Lawn/Paterson Fish Weir." *Bulletin of the Archaeological Society of New Jersey* 54, 1999.

Maxwell, James A. *America's Fascinating Indian Heritage*. Pleasantville, NY: Reader's Digest Association, 1978.

Native American Fishing Weir. "Six Methods for Catching Fish." http://rkc.org/Weir.html.

## SLOTERDAM: GARRETSON FARM AND THE FIRST HOUSE

*Bergen County Historic Sites Survey, Borough of Fair Lawn.* Hackensack, NJ: Bergen County Office of Cultural and Historic Affairs, 1982–83.

Copy of a portion of a surrogate's map showing the division of lands between Garret H. Garretson and John Garretson, 1822.

Farewell Mills Gatsch Architects LLC. *Garretson Farm, Historic Structures Report—Volume 1.* Hackensack, NJ: Bergen County Department of Parks, Division of Cultural and Historic Affairs, 2007.

Fogarty, C.M., J.E. O'Connor and C.F. Cummings. *Bergen County: A Pictorial History.* Norfolk, VA: Donning Company/Publishers, 1985.

*Garretson Gazette.* Untitled article (a translation of the indenture of 1708). Vol. 31, Issue 3, Winter 2007.

Klett, Joseph R. *Using the Records of the East and West Jersey Proprietors.* New Jersey State Archives, 2008. www.state.nj.us/darm/links/pdf/proprietors.pdf.

Wardell, Patricia A. "A Dictionary of Place Names in Bergen County, New Jersey and Vicinity." www.dutchdoorgenealogy.com.

## DUNKERHOOK: JACOB VANDERBECK AND HIS MILL

Bromley, G.W., and W.S. Bromley. *Atlas of Bergen County, N.J.* Vol. 2. Philadelphia: G.W. Bromley and Co., 1913.

Historic American Buildings Survey. "Jacob Vanderbeck House, NJ-563" and "Jacob Vanderbeck House, NJ-45 and NJ-45A." http://memory.loc.gov/ammem/collections/habs_haer.

Hopkins, G.M. *Map of the Counties of Bergen and Passaic, New Jersey.* Philadelphia: G.H. Corey, 1861.

Hughes, M., and T. Hughes. *Map from Palisades to Paterson, New Jersey.* Philadelphia: N. Friend, 1867.

Lutins, Allen. "Vanderbeck/Squire Home." Unpublished chart of property ownership information.

Walker, A.H., comp. *Atlas of Bergen County, 1776–1876*. Reading, PA: C.C. Pease, 1876.

## Dunkerhook: Myths, Facts and the Lafayette Connection

Ancestry.com. "United States Federal Census." 1850, 1860, 1870, 1880. http://www.search.ancestry.com.

Bal, Eric. "General Lafayette's Visit to Dunkerhook after the Revolutionary War." Typed manuscript, July 2008.

*Bergen County Historic Sites Survey, Borough of Closter*. Hackensack, NJ: Bergen County Office of Cultural and Historic Affairs, 1981–82.

*Bergen County Historic Sites Survey, Borough of Fair Lawn*. Hackensack, NJ: Bergen County Office of Cultural and Historic Affairs, 1982–83.

Garbe-Morillo, Patricia. *Images of America: Closter and Alpine*. Charleston, SC: Arcadia Publishing, 2001.

Historic American Buildings Survey. "Jacob Zabriskie Farm Group, NJ-157" and "Albert J Zabriskie House, NJ-271." http://memory.loc.gov/ammem/collections/habs_haer.

Lutins, Allen. "Dunkerhook: Slave Community?" *Journal of the Afro-American Historical and Genealogical Society* 21, no.1 (2002). http://www.lutins.org/dunkerh.html.

phillyBurbs.com. "The Passage to Freedom." www.phillyburbs.com/undergroundrailroad/NJroutes.shtml.

Rogers, Robert Q. *From Slooterdam to Fair Lawn*. Fair Lawn, NJ: Thomas Jefferson Junior High School, 1960.

Terhune, Albert D. "Military Career of Abraham A. Terhune Jr." Excerpted by Nancy Terhune from "Genealogy and Memorial History: With Reminiscences of Eight Generations of the Terhune Family." Unpublished manuscript, November 2008.

Walker, A.H., comp. *Atlas of Bergen County, 1776–1876*. Reading, PA: C.C. Pease, 1876.

## Lost Fair Lawn

*Bergen County Historic Sites Survey, Borough of Fair Lawn*. Hackensack, NJ: Bergen County Office of Cultural and Historic Affairs, 1982–83.

*Borough of Fair Lawn Twenty-fifth Anniversary Silver Jubilee*. Fair Lawn, NJ: Borough of Fair Lawn, 1949.

Bromley, G.W., and W.S. Bromley. *Atlas of Bergen County, N.J.* Vol. 2. Philadelphia: G.W. Bromley and Co., 1913.

Historic American Buildings Survey. "The Major Henry Lee Headquarters (Ryerson House)" and "Peter A. Hopper House." http://memory.loc.gov/ammem/collections/habs_haer.

Hopper, Maria Jean Pratt. *The Hopper Family Genealogy*. Montvale, NJ, 2005.

Lutins, Allen. "Croucher Farm/Hopper Farm." "Doremus Home." Unpublished charts of property ownership information.

Mitchell, Craig. *The Enterprise against Paulus Hook*. River Edge, NJ: Bergen County Historical Society, 1979.

New Jersey Writers' Project. *Bergen County Panorama*. Hackensack, NJ: Bergen County Board of Chosen Freeholders, 1941.

Richardson, William H. *Washington and "The Enterprise against Powles Hook."* Jersey City: New Jersey Title Guarantee and Trust Company, 1929.

Rogers, Robert Q. *From Slooterdam to Fair Lawn*. Fair Lawn, NJ: Thomas Jefferson Junior High School, 1960.

Salek, Jane, and Jim Storozuk, eds. *Fair Lawn Fiftieth Anniversary*. Fair Lawn, NJ: Borough of Fair Lawn, 1974.

Wright, Kevin. *The Haring-Cadmus House*. Manuscript report prepared for Fair Lawn Historic Sites Preservation Corp., 1996.

## An Indigenous Architecture

Bailey, Rosalie F. *Pre-Revolutionary Dutch Houses and Families in Northern New Jersey and Southern New York*. New York: Dover Publications, Inc., 1968.

Brown, T. Robins, and Schuyler Warmflash. *The Architecture of Bergen County, New Jersey*. New Brunswick, NJ: Rutgers University Press, 2001.

Historic American Buildings Survey. "Jacob Vanderbeck House, NJ-45." http://memory.loc.gov/ammem/collections/habs_haer.

## A House in the Country: How Fair Lawn Was Named

Ancestry.com. "United States Federal Census." 1850, 1860, 1870, 1880. http://www.search.ancestry.com.

*Borough of Fair Lawn Twenty-fifth Anniversary Silver Jubilee*. Fair Lawn, NJ: Borough of Fair Lawn, 1949.

Clayton, W. Woodford, and William Nelson. *History of Bergen and Passaic Counties, New Jersey*. Philadelphia: Everts & Peck, 1882.

Lutins, Allen. "Croucher Farm/Hopper Farm." Unpublished chart of property ownership information.

# THE MYSTERY OF GEORGE MORLOT

*Borough of Fair Lawn Twenty-fifth Anniversary Silver Jubilee.* Fair Lawn, NJ: Borough of Fair Lawn, 1949.

Magarelli, Mauro. (Article on disappearance of George Morlot.) *Herald News*, October 7, 2002.

*New York Times.* "City and Vicinity." March 18, 1894.

———. "Manufacturer Gone, Help Unpaid." March 6, 1894.

# HISTORY IN STREET NAMES

Ancestry.com. "United States Federal Census." 1850, 1860, 1870, 1880. http://www.search.ancestry.com.

*Bergen County Historic Sites Survey, Borough of Fair Lawn.* Hackensack, NJ: Bergen County Office of Cultural and Historic Affairs, 1982–83.

Bromley, G.W., and W.S. Bromley. *Atlas of Bergen County, N.J.* Vol. 2. Philadelphia: G.W. Bromley and Co., 1913.

"Development Map of Borough of Fair Lawn." Fair Lawn Engineering Department, 1973.

Diepeveen, Jane L. Interview with Ed and Evan Kuiken, May 28, 1998. Unpublished manuscript transcript.

———. (untitled) notes taken in 1952 and 1953 from subdivision maps filed in the Bergen County Courthouse.

Engineering Department of the Borough of Fair Lawn and Michael A Canger III. "Borough of Fair Lawn, 1924" (map). *Fair Lawn, 50 Years of Progress, 1924–1974.* Fair Lawn, NJ: Borough of Fair Lawn, 1999.

Gallion, Arthur B., with Simon Eisner. *The Urban Pattern.* Princeton, NJ, 1950.

Harley, F.E., and C.E. Harley. *Borough of Fair Lawn* (map). 1942.

Hopkins, G.M. *Map of the Counties of Bergen and Passaic, New Jersey.* Philadelphia: G.H. Corey, 1861.

Rogers, Robert Q. *From Slooterdam to Fair Lawn.* Fair Lawn, NJ: Thomas Jefferson Junior High School, 1960.

Verheeck, Sylvia. Letter to Jane Diepeveen, October 25, 2004.

Walker, A.H., comp. *Atlas of Bergen County, 1776–1876.* Reading, PA: C.C. Pease, 1876.

Washburn, Frederick. Copy of *Surveys Done for His Excellency George Washington by Robt Erskine 1778–1779 From the original in possession of the New York Historical Society.* Englewood, NJ: Edward L. Smullen, 1921.

Wright, Kevin. *The Haring-Cadmus House.* Manuscript report prepared for Fair Lawn Historic Sites Preservation Corp., 1996.

## THE BIRTH OF A BOROUGH

*Borough of Fair Lawn Twenty-fifth Anniversary Silver Jubilee.* Fair Lawn, NJ: Borough of Fair Lawn, 1949.

Diepeveen, Jane L., and Kathryn L. Lyle, eds. *Fair Lawn: Know Your Town.* Fair Lawn, NJ: League of Women Voters of Fair Lawn, 1970.

*Fair Lawn: Know Your Schools.* Fair Lawn, NJ: League of Women Voters of Fair Lawn, 1961.

*Fair Lawn: Know Your Town.* Fair Lawn, NJ: League of Women Voters of Fair Lawn, 1957.

Ferry, Theodore K., mayor. Letter to Mrs. Floyd Lyle, October 11, 1939.

*Know Your Town: A Survey of Fair Lawn, New Jersey.* Fair Lawn, NJ: League of Women Voters of Fair Lawn, 1943.

*Know Your Town: A Survey of Fair Lawn*. Fair Lawn, NJ: League of Women Voters of Fair Lawn, 1950.

*Paterson Morning Call*. "Anti-Slaveryites, Aborigines of Fair Lawn Want Protection." October 31, 1938.

Salek, Jane, and Jim Storozuk, eds. *Fair Lawn Fiftieth Anniversary*. Fair Lawn, NJ: Borough of Fair Lawn, 1974.

"To the Honorable Mayor and Council." Original petitions for the establishment of a police department in the archives of the Cadmus House Borough Museum.

Weglein, Walter. "Maurice M. Pine Library Marks 75 Years." *Community News*, September 17, 2008.

## INDUSTRY AND COMMERCE

Ancestry.com. "United States Federal Census." 1850, 1860, 1870, 1880. http://www.search.ancestry.com.

Broadway SID, Fair Lawn, NJ. "Broadway Vision Plan." http://www.broadwaysid.com/Broadway-Vision-Plan.pdf.

Diepeveen, Jane L. Interview with Ed and Evan Kuiken, May 28, 1998. Unpublished manuscript transcript.

*Explore Bergen County*. "Easton Tower County Historic Site, Paramus." Hackensack, NJ: County of Bergen, 1992.

*Fair Lawn: Know Your Town*. Fair Lawn, NJ: League of Women Voters of Fair Lawn, 1957.

Jastrab, Jerry, ed. *Fair Lawn New Jersey 1924–1999*. Fair Lawn, NJ: Borough of Fair Lawn, 1999.

*Know Your Town: A Survey of Fair Lawn*. Fair Lawn, NJ: League of Women Voters of Fair Lawn, 1950.

Rogers, Robert Q. *From Slooterdam to Fair Lawn*. Fair Lawn, NJ: Thomas Jefferson Junior High School, 1960.

## RECOLLECTIONS

Diepeveen, Jane L. Interview with Carol Greydanus Bennett, May 21, 2009. Unpublished manuscript transcript.

————. Interview with Ed and Evan Kuiken, May 28, 1998. Unpublished manuscript transcript.

————. Interview with Nick Vanore, November 12, 1998, and November 20, 1998. Unpublished notes from taped interview.

Jastrab, Jerry, ed. *Fair Lawn New Jersey 1924–1999*. Fair Lawn, NJ: Borough of Fair Lawn, 1999.

## THE FIRST FIRE AND POLICE DEPARTMENTS

*Borough of Fair Lawn Twenty-fifth Anniversary Silver Jubilee*. Fair Lawn, NJ: Borough of Fair Lawn, 1949.

Federal Writers' Project of the Works Progress Administration. *Fair Lawn's Fire Fighters*. 1938.

Jastrab, Jerry, ed. *Fair Lawn New Jersey 1924–1999*. Fair Lawn, NJ: Borough of Fair Lawn, 1999.

Salek, Jane, and Jim Storozuk, eds. *Fair Lawn Fiftieth Anniversary*. Fair Lawn, NJ: Borough of Fair Lawn, 1974.

## RADBURN: THE TOWN FOR THE MOTOR AGE

*Radburn Bulletin*. "Citizens' Association." August 13, 1987.

———. "Citizens' Association Review Committee on Election Procedures." November 19, 1987.

*Radburn Program of Educational and Cultural Activities 1932–1933.* Radburn, NJ: Radburn Association, 1932.

*Radburn Reporter.* "Sports and Recreation." September 1936.

Schaffer, Daniel. *Garden Cities for America: The Radburn Experience.* Philadelphia: Temple University Press, 1982.

Stein, Clarence S. *Toward New Towns for America.* Cambridge, MA: MIT Press, 1957.

## RADBURN: A MEMOIR

*Radburn Times*, nos. 1 through 4 (1938) and nos. 1 through 4 (1939).

Stein, Clarence S. *Toward New Towns for America.* Cambridge, MA: MIT Press, 1957.

## FAIR LAWN BECOMES A SUBURB

Anonymous manuscript on the building of Memorial Pool. N.d.

*Borough of Fair Lawn Twenty-fifth Anniversary Silver Jubilee.* Fair Lawn, NJ: Borough of Fair Lawn, 1949.

Diepeveen, Jane L., and Kathryn L. Lyle, eds. *Fair Lawn: Know Your Town.* Fair Lawn, NJ: League of Women Voters of Fair Lawn, 1970.

*Fair Lawn Advertiser.* "Group Says Boro Needs Plan Now." March 12, 1958.

*Fair Lawn: Know Your Town.* Fair Lawn, NJ: League of Women Voters of Fair Lawn, 1957.

*Fair Lawn News*. "They Also Serve Who Stand and Count." June 21, 1956.

*Fair Lawn News-Beacon*. "The Stroller." January 25, 1968.

*Fair Lawn–Radburn News*. "A Story of Civic Cooperation." August 6, 1948.

Jastrab, Jerry, ed. *Fair Lawn New Jersey 1924–1999*. Fair Lawn, NJ: Borough of Fair Lawn, 1999.

*Know Your Town: A Survey of Fair Lawn, New Jersey*. Fair Lawn, NJ: League of Women Voters of Fair Lawn, 1943.

Matule, Joseph F., mayor. Letter to Mrs. Katherine L. Lyle. July 27, 1955.

Salek, Jane, and Jim Storozuk, eds. *Fair Lawn Fiftieth Anniversary*. Fair Lawn, NJ: Borough of Fair Lawn, 1974.

## CHANGING THE GOVERNMENT—OVER AND OVER

Crane, Gigi. "Legality of Petitions Is Upheld by Higher Court." *Fair Lawn-Elmwood Park-Saddle Brook Shopper*, March 19, 1980.

Diepeveen, Jane L., and Kathryn L. Lyle, eds. *Fair Lawn: Know Your Town*. Fair Lawn, NJ: League of Women Voters of Fair Lawn, 1970.

Duhl, Ron. "Rival Democrats Endorse Charter Change Proposal." *News* [Passaic County, NJ], May 14, 1980.

*Fair Lawn-Elmwood Park-Saddle Brook Shopper*. "Petition Hearing Ends; Decision Expected Soon." January 16, 1980.

*Fair Lawn: Know Your Town*. Fair Lawn, NJ: League of Women Voters of Fair Lawn, 1957.

*Know Your Town: A Survey of Fair Lawn*. Fair Lawn, NJ: League of Women Voters of Fair Lawn, 1950.

Levitt, Marvin. "FLID endorses referendum." Letter to the editor. *Fair Lawn-Elmwood Park-Saddle Brook Shopper*, May 14, 1980.

*News* [Passaic County, NJ]. "Stay Partisan, Fair Lawn." May 16, 1980.

## FAIR LAWN UP TO DATE

Burdick, Roland, ed. *Fair Lawn: Know Your Town.* Fair Lawn, NJ: League of Women Voters of Fair Lawn, 1984.

Cameron, Joel. "Preserve Neighborhood Schools." *Fair Lawn-Elmwood Park-Saddle Brook Shopper*, August 8, 1979.

Crane, Gigi. "5–4 Vote Closes School; 9th Grade Will Move Up." *Fair Lawn-Elmwood Park-Saddle Brook Shopper*, January 16, 1980.

Diepeveen, Jane L., ed. *Fair Lawn: Know Your Town.* Fair Lawn, NJ: League of Women Voters of Fair Lawn, 1994.

Diepeveen, Jane L., and Elaine B. Winshell, eds. *Fair Lawn: Know Your Town.* Fair Lawn, NJ: League of Women Voters of Fair Lawn, 2004.

Librescu, Beverly. Minutes of the work session of the Fair Lawn Planning Board, August 15, 1983.

*Record*. "Growth: School Districts Pained." May 11, 1988.

# About the Author

Jane Lyle Diepeveen, a retired community planner, is the municipal historian for the borough of Fair Lawn, New Jersey, and a trustee and past president of the Fair Lawn Historic Sites Preservation Corp., which runs the borough's history museum. Ms. Diepeveen holds a degree in architecture from Washington University and an MS in urban planning from Columbia University. She is active in local historic preservation and civic affairs and served for many years on the Fair Lawn Planning Board, helping to guide the borough's growth. She is also a past president and longtime member of the League of Women Voters of Fair Lawn, having served on its board for five decades.

Visit us at
www.historypress.net